AKRON
BEER

AKRON BEER

A History of Brewing in the Rubber City

ROBERT A. MUSSON, MD

Foreword by Fred Karm

AMERICAN PALATE

Published by American Palate
A Division of The History Press
Charleston, SC
www.historypress.net

Copyright © 2018 by Robert A. Musson
All rights reserved

Front cover image by Ron Saari.

First published 2018

Manufactured in the United States

ISBN 9781467138185

Library of Congress Control Number: 2017958367

This work is dedicated to Margaretha Burkhardt, the first lady of the city's brewing heritage. A native of Germany, she overcame tremendous personal tragedy to oversee the rise of her family's brewery to become the city's largest and most successful. At the age of thirty-four, she lost both her husband, Wilhelm, and her young daughter, Carrie, within a span of five days in 1882. Instantly she was forced to choose between selling her husband's company or keeping it and running it herself, all while raising two young sons. Her decision to retain it and manage it successfully, despite being in a highly male-dominated industry, cemented her place in Akron's history. Her solid business sense, willingness to work hard and dedication to her family served her well over the next four decades, until her passing during the Prohibition era at the age of seventy-seven.

As the father of three young daughters, I am well aware of the challenges that women face in society and in the workplace and am happy to use Mrs. Burkhardt as an example for them to follow as they grow into young women, about to embark on their own careers.

CONTENTS

Foreword, by Fred Karm 9
Acknowledgements 11
Introduction 15

The Birth of an Industry 19
The George J. Renner Brewing Company 28
The M. Burkhardt Brewing Company 38
The Akron Brewing Company 52
The Dry Years 66
Happy Days Are Here Again! 75
The Postwar Years 88
The Industry Is Reborn 103
Craft Brewing in Akron Starts Over 114
Craft Brewing in Akron Today 126

Index 139
About the Author 144

FOREWORD

When considering the history of brewing in Akron, it's amazing how much the craft beer industry has grown here throughout the last quarter century. A few breweries were established by the end of the 1980s, and a clear ramp-up seemed to start in Akron in the mid-1990s with the birth of the Thirsty Dog brewpubs and other craft breweries.

This was craft beer's honeymoon period, which saw unprecedented growth in many parts of the country. In those days, it was like the Wild West in many ways, where the saying quickly became "If you brew it, they will come." This growth continued in Akron and the surrounding areas for several years. But there was a fallout in 1999 and 2000, where the supply eventually overtook the demand. By early 2005, there were no breweries left in Akron.

However, the brewers and craft beer lovers in Akron wouldn't rest. Growth started over again in 2006 with the opening of my Hoppin' Frog Brewery, followed by a rebirth of the Thirsty Dog Brewing Company the following year. Now, ten years later, we are seeing explosive growth of the craft beer industry once again in Ohio and all across the country. Akron is definitely in the middle of it all, with several more craft breweries established in 2017 and many more to come.

The question may soon become, "Can these craft breweries attract enough customers for all of them to survive?" With the spread of knowledge and the excitement of craft beer in Akron, it seems there could

be prosperity and growth in this industry here for a long time—maybe even sustained growth for years to come. All craft beer lovers certainly hope for this.

The future growth of breweries in America seems to be the most promising in facilities that make and serve their own beer, similar to what was often seen in the nineteenth century, decades before Prohibition. Establishments that make and serve their own beer often win the hearts of the local patrons and energize their respective communities. Akron has certainly had its fair share of breweries, and the number keeps growing. It goes without saying that craft beer lovers in Akron will continue to support their local breweries, assuming that the beers are high quality and meet the customers' expectations.

—FRED KARM

ACKNOWLEDGEMENTS

I began writing about Akron's brewing industry in 1994, during the early years of the city's craft brewing industry, and this led to my first self-published book, *Brewing Beer in the Rubber City* (1997), and the subsequent *Brewing Beer in the Buckeye State*, vol. 1 (2005). As I continue to research and write on the subject today, there are many people whom I would like to thank for their assistance and support over the years.

First, I want to thank my family for their support of my writing. My late parents, Irv and Frances Musson, were always enthusiastic about my research in the early days, and today my wife, Jennifer, and my daughters, Anastasia, Alexandra and Athena, remain supportive and excited about these projects.

One person who has been endlessly helpful over the years is Bill Carlisle. A collector of brewery history, relics and advertising since 1973, he has amassed a huge assortment of these and has provided information and images for my books on many occasions.

Carl Miller is another individual who has been tremendously helpful on my writing projects for more than twenty years. The author of *Breweries of Cleveland* (1998), he has provided me with many tips on writing style and the art of self-publishing.

Thomas Burkhardt, the founder and operator of the Burkhardt Brewpub, was extremely helpful during the writing of my first book. In addition to providing information about his modern brewing operation, he allowed me to reproduce many rare images of his family's previous brewery in Akron, several of which appear in this book.

Rick Armon is a prominent writer for the *Akron Beacon Journal* and has been covering the area's craft brewing industry for many years. His columns and his online blog have documented the rapid changes of the industry in great detail over the past decade, and these have allowed my coverage of the modern era of brewing to be far more complete.

Fred Karm, the founder and operator of the Hoppin' Frog Brewery, was kind enough to provide images of his facility and the foreword to this book. With more than twenty years of experience in professional brewing, he knows the local industry as well as anyone.

The staff of the Akron–Summit County Public Library have been very helpful over the years, providing resources from their collection and allowing me use of their microfilm readers.

Kevin Wise, a friend for more than forty years, has provided endless technical support, helping me to get established with a home computer system in the early 1990s that started the ball rolling on the path to self-publishing.

Dale Van Wieren, a brewery historian on the national level, has spent many years documenting and publishing lists of known breweries in the United States. His *American Breweries II* (1995) is considered a landmark publication for brewery researchers like myself.

Bob Kay has amassed the largest collection of United States beer labels, many of which are extremely rare. He has allowed me to use images of many of these in this publication and other books I have written.

Don Augenstein is another collector of brewery artifacts, particularly paper items and photos, and he has graciously allowed me to use many of these in this and other book projects.

Robert and Sara Hernandez are the owners of the Aqueduct Brewing Company, and I would like to thank them for their efforts to restore and utilize the former Burkhardt Brewery as part of their own facility, as well as for allowing me to tour the plant's underground rooms while they were being renovated.

Similarly, I would like to thank John Najeway for allowing me to tour the entire plant a decade ago, as well as thank him and Thirsty Dog Brewing for saving the historic Burkhardt Brewery from what would otherwise have likely been a wrecking ball (as we saw with the Akron Brewing Company in 2016).

I would also like to thank John Rodrigue, my acquisitions editor at The History Press, for his assistance and advice during the process of writing this book.

ACKNOWLEDGEMENTS

My path to writing this book has crossed those of many other individuals over the years, and I would like to collectively thank all of them for their help in gathering information for this project.

It should be noted that unless otherwise indicated, all images presented here are from the author's collection.

INTRODUCTION

R apidly approaching two centuries in length, the history of Akron, Ohio, has consisted of repeated cycles of success and failure. Therefore, it should be no surprise that its brewing industry has followed a similar series of ups and downs since the first beer was brewed within a few feet of the Ohio & Erie Canal. Known throughout the twentieth century as the "Rubber Capital of the World," its national reputation in modern times is more diverse, often relating to the University of Akron and polymer science, the Rubber Ducks baseball team or being the home of basketball legend LeBron James. However, in some circles, it has also become known as the home of some of the nation's best craft beers. But how did we get to this point? That is a story that has been more than 170 years in the making.

Unlike cities such as Cleveland, which were truly "founded" at a specific point, Akron's origin was more of an evolution over time, as three separate communities gradually grew together. The land that eventually became Akron (as well as most of Northeast Ohio) was part of the Connecticut Western Reserve until 1800, and as a result, its founders and many early residents were from the Nutmeg State. The area was very sparsely populated before the construction of the Ohio & Erie Canal, with the exception of the village of Middlebury. Founded in 1804, that village stood along the Little Cuyahoga River and would later make up a large part of east Akron.

Once the State of Ohio made plans to build the Ohio & Erie Canal, early settler Paul Williams and his partner, Connecticut native General Simon

Perkins, purchased a large tract of land that would later become downtown Akron. Having done that, they succeeded in convincing the state to adjust the canal's course to flow through the land that they owned. In the process, the partners laid out a small town in 1825 that included a public square, land for public buildings and two canal basins. Its name was Akron, from the Greek word for summit, due to the fact that it was situated at the high point along the future course of the canal.

Construction of the canal began in 1825, and the first segment from Akron to Cleveland was finished two years later, allowing regular transport of passengers and cargo between the two cities. Upon its completion all the way to the Ohio River at Portsmouth in 1832, a direct route of transportation existed between the Great Lakes and the Gulf of Mexico for the first time. Traffic on the canal increased dramatically after that, and the resulting increase in travel through Akron created a demand for more hotels, saloons, markets, mills, lumberyards and so on, leading to rapid growth in the town's economy. As more farms appeared in the surrounding countryside, farmers were able to bring their crops to sell in Akron, where they could be transported long distances to other markets.

By this time, General Perkins and two other Connecticut natives, Dr. Eliakim Crosby and Seth Iredell, had established a second village just north of Akron. Known as Cascade, it was built to take advantage of the falling water of the canal, which could provide power to new industries. Eventually known as North Akron, it was merged with South Akron into one town in 1836, at which time Iredell was elected as its first mayor. Middlebury would eventually be incorporated into Akron as well, although the union came more than three decades later. By that time, shortly after the Civil War's end, the canal was no longer the primary mode of transportation through the region, having been largely replaced by railroads (the canal did remain in operation, transporting some freight and providing a water supply to businesses, until 1913).

As the area's earliest settlers were mostly from Connecticut, nearly all were of English extraction, with some Scottish ancestry mixed in. The ethnic mix began to shift with the canal's construction, however, which brought in many European immigrant workers. While most were Irish, some were Germans, and many of them remained in the area after the canal's completion. More Irish immigrants would come to America in the 1840s due to the potato famine and other hardships at home; around the same time, increasing numbers of German immigrants also began to appear due to political and military instability in the Fatherland. From

the 1850s on, the number of German immigrants in particular was large enough to make a cultural difference in Akron, one that would certainly affect the brewing industry.

Appropriately enough for this story, the first structure to be built in the new city was Clark's Tavern. Built in 1826, just one year after the town's formation, it was located at the northeast corner of Main and Exchange Streets. In addition to serving alcohol, it was an important social meeting point for the town's early residents—important enough, in fact, that the town's first mayoral election took place there in 1836. Whiskey and harder spirits were likely to have been the beverages of choice there in the early days, as consistent sources of beer and ale were few and far between.

Although specific records have not surfaced, it is more likely than not that some small-scale brewing took place in and around the Akron area in the early days. Several small farm-based breweries are known to have operated in the area in the 1830s and 1840s, and it was also common for some saloons and hotels to have small brewing operations on the premises. These were typically comparable to modern nanobreweries, producing one or two barrels or less at a time for patrons of the establishment. One can only speculate about beer and ale production in early Akron, but it is also likely that a small amount of each beverage was brought in by canalboat from some of Cleveland's fledgling breweries as early as the 1830s.

Akron would eventually develop a commercial brewing industry of its own, but not until the mid-1840s. Even then, it remained small by most standards until the 1880s, after which time it grew quickly to accommodate the beverage needs of its rapidly growing working-class population. Sit back now with one of Akron's great craft beers and read about the ups and downs of more than a century of Akron beer.

THE BIRTH OF AN INDUSTRY

The evolution of Ohio's brewing industry was sporadic and inconsistent from one region to another. While the earliest documented breweries in the state (mostly small one-room pioneer operations that produced only enough common beer or ale to supply a nearby tavern) were established prior to achieving statehood in 1803, the first one known to exist in Northeast Ohio was the Canton Brewery, which opened in 1817. However, Cleveland's first known brewery was not established until fifteen years later, and in Akron, the industry had a particularly late start in 1845.

Part of the reason for Akron's late entry into the brewing industry was that the town remained relatively small over its first four decades of existence. In the early 1840s, its population was just over 1,600, and they were adequately supplied with beer and stronger spirits from breweries and distilleries in Cleveland, brought in via the canal. By the onset of the Civil War in 1861, the city's population had doubled to more than 3,000, a number that justified the city's two operating breweries. However, Akron's post–Civil War industrial boom tripled the city's population to more than 10,000 by 1870, and with many of these new arrivals being from Germany, the market for beer (and especially lager beer) suddenly increased dramatically, opening up the potential for more brewing activity. Although Akron never had the vast number of brewers that larger cities like Cleveland had, its two primary breweries did see tremendous success over the coming decades prior to Prohibition.

Akron had counted some native Germans among its population from the early days, but unlike larger cities such as Cincinnati, Pittsburgh and Cleveland, it did not see a huge influx of German immigration in the 1840s and 1850s, largely because the city's industrial base was still in its infancy. After the Civil War, however, the city became home to large cereal mills and factories producing clay products, farm equipment and other items, and it was at that time that German immigration to the city began to accelerate. While Akron did not have an especially large German district like the other cities listed, much of its new immigrant population settled in an area that was generally bounded by East Exchange Street on the north, South Street on the south, Grant Street on the west and Brown Street on the east. Over the years, it was often referred to as "Goosetown," as many of the German residents kept geese in their yards. Much of the city's German culture was centered in that neighborhood, with Turner Halle, a large gymnasium and meeting place for young Germans, built in 1885 on Grant Street. While only one of Akron's breweries would be established in this neighborhood, it would ultimately grow to be the largest and most extensive one in the city.

Until the 1850s, nearly all breweries were producing ales or common beer. Ale (and related beverages such as stout and porter) was particularly popular with English and Irish populations of the era, although those that were available in Akron at the time were typically very basic pale ales, as opposed to the India pale ales and other varieties available today. Ale was top fermented (with the yeast staying at the top of the fermenting vessel during the aging process) at relatively warm temperatures and generally did not utilize hops in its production. It was aged for varying lengths of time, anywhere from a few days to a few weeks.

Common beer was made in a similar way but often had hops added to the brew. It was typically aged for a very short time, leaving relatively little carbonation, but as a result, it tended to spoil more quickly than ale, requiring that it be consumed fairly soon after brewing. Also known as table beer, it was slightly sweeter than ale and was popular among the laborers who populated early Akron. Individual brewers often varied their brewing processes based on their training, taste, availability of various ingredients and the culture of the local population so that an ale or beer in one area might vary significantly in taste from that produced elsewhere. Since most workers at the time did not possess particularly refined palates, they were usually satisfied with whatever the local breweries produced.

Once the tide of German immigrants in Akron began to increase from the 1850s onward, they brought with them a relatively new style of beer that had first appeared in Germany a few years earlier: lager beer (although some forms of lagering had taken place centuries earlier in Europe, the specific process that became popular in the nineteenth century was only recognized in the mid-1800s). While the time and location of the first appearance of lager beer in America has been debated many times, it was most likely around 1840, and the style was so overwhelmingly popular that it spread across the growing nation quickly.

From a technical standpoint, lager beer requires a specific type of yeast for fermentation; it differs from ale in that it is bottom fermented and differs from common beer in that it requires a long aging process, sometimes several months in length (*lagern* in German means "to store"). However, the aging process must take place at a constant cool temperature, which required significant changes to be made to existing breweries before lager could be brewed. If natural caves were not available nearby, large underground cellars could be dug, usually by hand and at great expense, to ensure a constant temperature. If digging caves was not an option, a well-insulated icehouse could also be used, with ice brought in during the winter from a nearby pond, lake or river in hopes that it would remain frozen over the warmer months. Once mechanical refrigeration appeared in the late nineteenth century, underground cellars were no longer needed, making the process much more efficient.

Lager beer has remained the dominant style of beer in Germany and America for well over a century, although numerous variations have evolved, based on recipes made popular in various European cities (Münchner, Würzburger, Budweiser and so on). In a trend that began shortly before World War II and continued into the 1950s, the most enduring style in America became pilsner beer, made popular in Pilsen, Czechoslovakia. A lighter-bodied beer, it appealed to both the brewers and consumers: one could drink it in larger quantities without getting as drunk, and it tended not to leave as much of a hangover the following day. The advantage for a brewer or bartender was a huge increase in sales. Until the dawn of the craft brewing era, nearly all mass-produced beers in the United States were pilsner beers, in various styles.

As Akron's early years centered on the Ohio & Erie Canal, it is no surprise that its first documented brewery stood along its bank. John T. Good, a native of Alsace-Lorraine, on the border of Germany and France, arrived in America in 1838 and had only lived in Akron for three years when he

established this small plant in 1845 with partner Michael Bittman, a German immigrant. Standing just north of downtown, the small wooden frame plant was located near Lock 11 of the canal and the Aetna Mills.

Although today it is known only for the Cascade Valley Park and the Towpath Trail along the canal, the area was home to the city's earliest hub of industrial activity. Located on the edge of the Little Cuyahoga River Valley, the canal rapidly descends nearly two hundred feet through a series of locks from downtown to the level of the river; the water flow served to power many of these early industries. The course of the canal through this section was no accident, as its planners had recognized that canal traffic would take hours to travel through the series of locks, allowing travelers to patronize businesses and saloons along the way, thus creating an immediate source of revenue in the new town.

Good and Bittman found a ready market for their ale and common beer with all of the canal traffic passing their business on a daily basis. Bittman sold his share of the company to Good in 1850 for $500, although he remained as an employee, running the plant over the next year while Good traveled to California with more than two hundred other Akron men as part of the legendary California Gold Rush. Like many others who ventured westward at that time, Good did not strike it rich; in fact, poor health prevented him from spending much time in the mines. Instead, he operated a small grocery store for several months before returning to Akron. In 1855, he sold a partial share in the brewery to his cousin Jacob Good as business continued to grow. Although it was not advertised heavily, the partners began brewing lager beer at some point as more Germans arrived in the city, creating a growing market for the popular beverage.

The Goods had outgrown the small frame brewery by 1861, at which time they moved their brewing operation to the center of the city's business district, on the west side of South Howard Street. This new building was three stories in height and built of brick and stone, and it contained a deep vaulted cellar for beer storage and for the lagering process. The building also contained space for a grocery store, which John Good had established with his profits from the brewery. Shortly after this, however, the Goods sold the brewery to Jacob Guth, another Alsacian, and he remained in business until the early 1870s, when the plant closed. John Good, meanwhile, had purchased an oil refinery, which eventually made him a very wealthy man. His son, J. Edward Good, later established a hardware supply business and gave a large tract of land to the city. On that land stands the Good Park municipal golf course, which still operates today on the west side of town. The

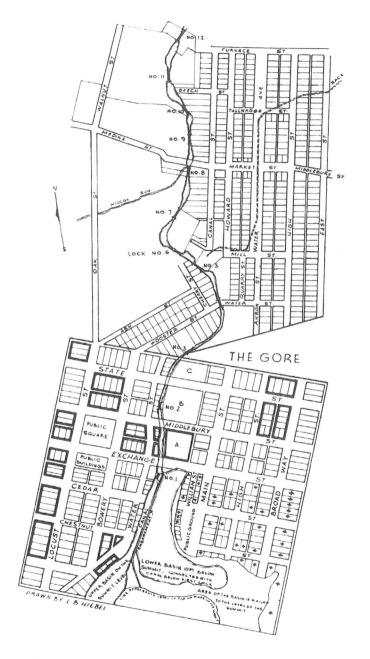

In this map of early Akron in the mid-1800s, the John Good Brewery would have been just west of Lock 11, near the top of the diagram.

brewery building was home to a number of businesses in later years and was finally demolished in the late 1960s as part of an urban renewal project that eliminated a large swath of early Akron buildings and history.

Perhaps the least well-known brewery of the city's early days was that of Marshall Viall, a native of New York who moved to Akron in the 1840s. After settling in the village of Middlebury, roughly three miles east of downtown Akron, Viall purchased property near the present-day intersection of Bank and Williams Streets in 1846. Here he operated a small brewing operation for several years, supplying local residents with common beer and ale. A beer bottle factory operated nearby, although it is not known whether he had any connection to it. The area surrounding the valley of the Little Cuyahoga River was rich with clay, leading to the development of several related industries such as stoneware, sewer pipes, bottles and so on. Viall's brewery had closed by 1855, after which he went into farming. The village of Middlebury was annexed into the city of Akron just over a decade later.

Another lesser-known company from the early days was the South Akron Brewery, which was located on the east side of South Broadway, just south of Cedar Street and along the city's main railroad line (originally used by both the Atlantic and Great Western and the Cleveland, Mount Vernon and Columbus railroad companies). Established in 1864 by Conrad Fink, a thirty-three-year-old native of Darmstadt, Germany, the brewery occupied three small frame structures and produced small amounts of ale and common beer. Fink was joined in the business by brothers John and William, but all three had sold their shares by 1866 to Frenchman Jacques Lockert.

Although specific production numbers are not available, the brewery must have operated with a moderate degree of success; when it was sold in 1870 to Swiss immigrant Joseph C. Wirth, the price was $8,000, a significant amount at the time. Wirth was soon in over his head, however, with debts of more than $1,500 after just one year. As a result, the property was sold at a sheriff's auction the following year, as brewing operations at the site came to an end after just eight years. The buildings were later dismantled, and the property was used by various railroad companies for many years. Today, the site is occupied by student housing for the University of Akron.

Another brewer who operated on the city's east side was Fred "Fritz" Horix, a name that would remain prominent in the city for decades to come. A native of Darmstadt, Hesse, Germany, Horix completed his formal schooling before being apprenticed in the brewing and malting industry for several years. Like many other Germans, he came to America in 1868 to avoid military service. As a large man (over six feet in height), it was almost

a certainty that he would have been drafted into Otto von Bismarck's army during this turbulent period in German history. After working for a year in a Cleveland brewery, he moved south to Akron, where in 1870 he established his own plant on the north side of East Exchange Street, between Fountain and Beaver Streets. Working with his father-in-law, John Kirn, he was soon producing more than two thousand barrels of ale and lager beer per year. As business continued to grow, he found himself in need of more space by 1879; at that time, he purchased the vacant Oberholtz Brewery on Forge Street.

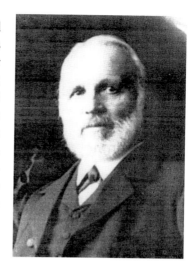

Fred Horix in his later years.

Horix's name will also appear later in this book. He operated the Forge Street Brewery for nine years before going into the saloon business. In that position, he was one of the original investors in The Akron Brewing Company after the turn of the century. Years later, in April 1938, writer John Botzum paid tribute to Horix in the *Akron Times Press*:

> *Just before he died in 1931, Mr. Horix had come back to the old town to look around. On that occasion, I met him at the Portage Hotel on the site of the famous old Empire House. It was to be the last meeting with him. Seated in the lobby of the hotel, he looked about. "How different, how different from the old days," he said. "I came back to see my old Akron but it is gone. I came back to see old friends but I guess they are gone."*
>
> *Mr. Horix, then and there, told me the story of his life, which was hardly necessary for I had known him for many years. He was born in Germany in 1843. When he was 24 he came to America. Two years later he came to Akron to show the town how to make beer, and to prove that even a gentleman could engage in such business. In 1888 he disposed of his brewery interests and opened his little High Street place of good cheer, close to Market Street. It was a side street and people wondered why Horix didn't locate downtown. "In time they will learn to come to me," he replied, and how they did come for the many years that followed. Judges, lawyers, doctors, manufacturers, actors, and most of the professional men of all kinds learned to know the way to his place. All knew that a cultured*

German gentleman presided there. All knew the quality of the old man's imported wines, cheese, and his many delicacies.

And so Fred Horix established himself, as other good Germans before him had done, in the hearts of thousands of Akron citizens. Always a respecter of law and order, he would and did make his place a house of respectability, a meeting place where good fellowship prevailed. All his patrons understood that. He was proud to be called a German and was always proud of the fact that the leading men of the city were his friends. There were others of his kind here in the early days of Akron, when German citizenship was establishing itself here. But Horix stood out among them all with his little dispensary of good cheer and good will.

There came a time when Fred Horix had to close his famous place. Akron was fast becoming a great city, and an old order was giving way to something new. Men no longer had time to be sociable. Fortunes had toppled. Men, who once were rich, had now become poor. It was to be a different Akron. Horix drew down the curtains of his place, turned out the lights, and locked the door. High Street was seeing the passing of a good man and a famous place. He went back to his old home in Germany to find friends. But most of them were gone. Then he came back to his Akron to try and find old friends. But most of them were gone, too. "It's all so different now," he said. It was his last trip here. Up in Liedertafel Hall [the city's German society], you may yet hear them tell the story of Fred Horix.

The city's other two nineteenth-century breweries stood on Forge Street (purchased by Fred Horix in 1879) and on Grant Street. Both started small before their purchases by the Renner and Burkhardt families, respectively, led them to great success that would continue well into the next century. Both are covered in detail later in the book.

Although most early brewing in Summit County took place in the city of Akron, three small nineteenth-century facilities operated in outlying communities, the first being in the village of Uniontown, twelve miles southeast of Akron. Located on the west side of what is now Church Street, a wooden frame brewery was established circa 1852 by Philip Seesdorf. Although little is known about the brewery itself, it appears that it saw only limited success, changing hands three times over the next thirteen years. The final owner, Jonathan Hubler, sold it in 1865 to satisfy debts, at which time brewing came to an end.

Around the same time, another brewery opened in the village known as Cuyahoga Falls, several miles north of Akron. Joseph Clarkson was a thirty-

two-year-old Englishman who had recently come to America, and in 1856, he established the Cuyahoga Falls Brewery along the Pennsylvania & Ohio Canal, at the northwest corner of modern-day Broad and Main Streets. All that is known about it comes from *One Hundred Years of Brewing* (a landmark 1903 book that gives an extensive history of the brewing industry in North America to that time): "He first commenced brewing with a small iron kettle having a capacity not to exceed two barrels. Afterward he put in a copper kettle with a capacity of about five barrels. The output never exceeded 25 barrels per week. All operations were performed by hand, there being no machinery or power used. Both ale and lager were manufactured. Clarkson died June 22, 1873, and the business was then permanently discontinued."

Two decades later, a small brewery was established in Norton Township, in an area that was later incorporated into the town of Barberton. Charles W. Specht was a German immigrant who had settled in the area in 1881. In 1894, he established a small weiss beer brewery near his residence on the south side of Hopocan Avenue, near Wolf Creek. Weiss beer was a light bodied, top-fermented, wheat-based beer of relatively low alcohol content that never attained the level of popularity of lager beer. Despite that, it had a limited but loyal following in the late 1800s, with several small breweries producing it in Cleveland and other cities. Specht operated the only one in the Akron area, producing between one hundred and two hundred barrels per year. After his death in 1898, his widow, Christina, continued brewing for another four years before closing the facility in 1902.

THE GEORGE J. RENNER BREWING COMPANY

The brewery that Fred Horix purchased in 1879, on the south side of Forge Street, had its origins three decades earlier and would remain in operation into the middle of the following century for a total of 104 years. Located in a ravine along the hillside where Forge Street descended into the valley of the Little Cuyahoga River (near an area that had long been known as the "Old Forge"), it was near a natural spring that was able to provide up to five thousand barrels of pure water every day. The hillside made it relatively easy to dig underground caves for aging lager beer, and the site was adjacent to both the Pennsylvania & Ohio Canal and the Atlantic & Great Western Railway tracks. All in all, it was probably the most ideal site in the area for the establishment of a brewery. At the time of its formation, the site was outside the city limits, in Portage Township, although it was annexed into the city in 1869. At that time, its address was 313–15 North Forge, although when the numbering system was changed years later, the address became 247–75 North Forge.

The property was originally purchased in 1848 by German immigrants John Brodt and George Harmann, and a small frame brewery was built shortly thereafter. Little is known of the early days of brewing at the site, although its founders sold the plant in 1855 to shoe dealer George Kempel. Like John Good, discussed previously, Kempel was involved in the same expedition of Akronites who had taken part in the California Gold Rush in 1850, looking unsuccessfully for riches in the Sierra Nevada Mountains (along with more than 300,000 people from all over the world,

most coming away with nothing or, worse, a bad case of cholera). Kempel retained ownership of the brewery for more than a decade before selling it in 1866 to Christopher Oberholtz.

Oberholtz was a forty-four-year-old German who had come to Akron in 1842 and had previously purchased a large amount of land surrounding the brewery. He had been a cooper by trade before entering the brewing field himself; there he was also successful until dying of pneumonia in 1869. The brewery was then willed to his wife, Susannah, and his son, Frederick. Business continued successfully until June 10, 1873, when disaster struck.

Nineteenth-century brewers faced many challenges, but none was greater than the danger of fire. Most early breweries were made largely of wood, and they could quickly go up in flames if ignited by the fire used in the brewing process, from a spark from a passing train, from arson or even from a wayward Roman candle landing on the roof (all of these were documented reasons for Ohio breweries being destroyed by fire in the 1800s). Although the exact cause was not determined, the Oberholtz brewery caught fire at 3:00 a.m. that morning, and the main brew house was destroyed along with the barley and hops on hand. Luckily for Oberholtz, the cold storage room was saved, along with fifteen thousand kegs' worth of beer in vats and tanks at the time. The overall loss was estimated at $13,000, but only $5,000 of that was covered by insurance.

This situation gave Oberholtz two choices: walk away from the brewery altogether or gamble on rebuilding it. He chose the latter option, constructing a three-story building of stone and brick at the site, with underground stone lagering cellars. Once this was completed in 1874, he was the owner of the city's largest and finest brewery, but he also found himself $30,000 in debt. While business was moderately successful, it was not enough to pay off debts of that magnitude (nearly $600,000 today), forcing him into default and losing the brewery to several creditors. It appears that the brewery sat quietly for the next two years until coming into the hands of John Kolp, who attempted to operate the brewery for a few years. However, he soon found himself heavily indebted as well, leading to the plant being sold at a sheriff's auction in January 1879. It was at that time that Horix reentered the picture, purchasing the property and buildings for a total of more than $8,300, which was two-thirds of its appraised value. With more than a decade of experience in the brewing industry, both in Akron and in Germany, Horix was the right man at the right time, enabling the brewery to finally see success and growth in its future.

Although the relatively new brew house and nearby icehouse had an annual capacity of twenty thousand barrels (a number that was unusually high based on the size of the city and the local beer market at the time), Horix invested even more money into the plant, bringing the equipment fully up to date and allowing business to restart in the summer of 1879. Just one year later, however, another devastating fire broke out at the brewery, again starting in the middle of the night. Beginning in the boiler room, it spread quickly through the plant. Living in a house next door to the brewery, Horix saw the fire and immediately ran up the steep Forge Street hill (still in his nightclothes) to the nearest fire alarm box, which was a full half mile away. The fire department responded quickly, yet the top two floors of the brew house were gutted, causing damages in excess of $12,000. Fortunately, Horix had the foresight to fully insure the plant, and it was quickly rebuilt; brewing operations were interrupted for only a few weeks.

By the mid-1880s, Akron's population had topped twenty thousand and was continuing to grow rapidly, with an increasing number of newcomers being European immigrants. Horix's business continued to grow as well, with annual production of nearly seven thousand barrels; this necessitated further

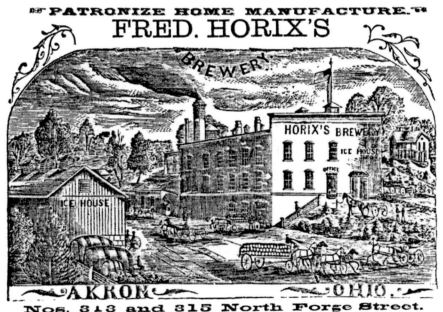

Advertisement for the Horix Brewery; built in 1873, the main building shown here remains part of the Renner Brewery complex today. *From the* 1881 Summit County Atlas.

enlargements of the plant, and by 1888, it consisted of seven separate buildings. That same year, Horix chose to leave the brewing business, selling the plant to fellow native German George J. Renner; the sale price of $45,000 gave Horix a tidy profit on his original investment. The deed of transfer specified that Renner would take ownership of the brewery and house, but it allowed Horix to retain his personal records, family furniture and a "spotted horse called Dick." Horix then spent a year in Germany visiting old friends; upon his return, he eventually opened the aforementioned delicatessen and saloon on High Street.

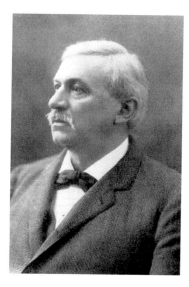

George J. Renner, circa 1890. *From One Hundred Years of Brewing.*

By the time George Jacob Renner came to Akron, he already had been in the brewing business for nearly forty years, having worked in multiple Ohio cities along the way. Born in Dannstadt, Bavaria, in 1835, Renner had come to America in 1849 to avoid military service. Like Horix, he was a large man, standing well over six feet in height and weighing 260 pounds, and it was a near certainty that he would have been drafted into the state army. Living initially in Cincinnati, he attended brewing school before working for a succession of brewers in both Cincinnati and Covington, Kentucky. By 1881, however, he was ready to operate his own company and thus moved north to Wooster, Ohio, where he purchased a small rural brewery with his son, George Jr.

Two years later, Renner established a partnership with Henry Weber of Mansfield, who had recently purchased a brewery there. Renamed as the Renner and Weber Brewing Company, it was enlarged and subsequently operated successfully until the arrival of Prohibition. Renner, however, was only involved in the plant's operation until 1888, when he moved to Akron. After this, he put operation of the Mansfield plant in the hands of John Weaver, who had moved north from Covington at the same time (Renner, Weaver and Weber would eventually all become part of the same family through intermarriages of various descendants; this was a common scenario among prominent German brewers in America). Despite living in Akron, Renner would continue to be the Mansfield company's president for many years.

Meanwhile, George Renner Jr. had left the partnership with his father in 1885, when he moved to Youngstown, Ohio, to purchase a struggling brewery there. Born in 1856, the younger Renner had trained with several Cincinnati brewers beginning at the age of fifteen and was well prepared for a career in the field. Four years after assuming ownership of the Youngstown plant, however, his brewery burned to the ground in a spectacular fire. Once rebuilt in 1890, the new Renner brewery, at 203–209 Pike Street, was a large and architecturally impressive structure. George's descendants would continue to produce beer at the plant until 1962.

Back in Akron, George Renner Sr. took ownership of a thriving business and immediately began to take steps to expand it even further. His first investment was in a mechanical ice machine, which produced forty-five tons of ice per day for cooling the plant's storage cellars. There was enough extra production, however, to begin a side business of selling "Renner's Crystal Ice" for home use, for which the company purchased several wagons to make deliveries throughout the city. A second ice machine followed in 1895. By this time, George had been joined in the business by his youngest son William, while his daughter Eleanora ("Nora") served as the company's secretary and treasurer, and his son-in-law, Ernest C. Deibel, served as brewmaster and plant manager. Deibel was a Youngstown native, and after marrying Renner's daughter Elizabeth, he had studied at Chicago's famed Wahl & Henius Brewing Academy. Family always came first for most of the early German brewers, and their companies were often staffed primarily (if not entirely) by family members.

With most of the brewery still operating out of the three-story building that had been built twenty years earlier, the company's growth necessitated extensive updates to the plant and its equipment over the next few years. This was funded by $60,000 of capital stock, which came from the brewery's incorporation in 1893. Unlike many breweries of the era, which attracted outside investors and were rebuilt from the ground up with large, architecturally impressive towers, Renner added buildings as needed, leaving the plant as a nondescript hodgepodge of structures on the hillside. A five-story cold storage building was added in 1895, followed by a three-story bottling plant in 1897. Employing twelve men, the bottling works was capable of filling five hundred bottles per day (in the days before mechanized bottling equipment would dwarf those numbers). Prior to this, the company had utilized local bottlers that were off the premises, as was required by law until 1890.

Part of the renovation project included a new three-story building to hold the company's offices. Built in the style of the large breweries in Munich,

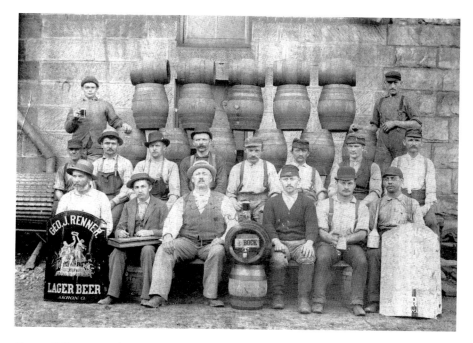

George J. Renner posing with employees and kegs of bock beer, circa 1890s.

Germany, it was often referred to as the "München office" and showed how much these Germans still missed their homeland. Walls were painted with scenes of the Rhine Valley, and stucco trees projected into the room to give one a feel of being in a traditional beer garden. One wall was painted with the image of George and friends drinking beer and smoking cigars; this same image appeared on Grossvater Beer labels in the 1930s. The room remains intact today.

Around the same time, a three-story stable building was added to hold the company's fifty draft horses that were used for deliveries. This was followed by the addition of three new grain elevators. The final addition was an entirely new, four-story brew house, with a three-hundred-barrel copper kettle. New storage tanks, made of California redwood, were added as well. By the turn of the century, the plant was capable of producing fifty thousand barrels of lager beer per year, although the actual production numbers were roughly half of that number.

By the first decade of the twentieth century, saloons had developed a tainted reputation among much of the public, a reputation that was amplified by the Anti-Saloon League and others who were working hard

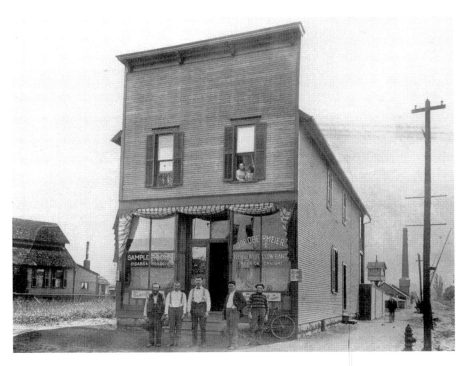

Joe Obermeier's saloon on South High Street in south Akron, where Renner's beers were on tap, circa 1900. *Al Sutter Collection.*

to eliminate alcohol from society. Although there certainly were some saloons that were dirty, smoky places that harbored violence and crime and encouraged alcoholism, many saloons and restaurants where beer was served were fine, clean establishments. Nevertheless, an increasing portion of the public was choosing to avoid saloons in general. As a result, bottled beer became increasingly popular, allowing one to drink beer at home, on a picnic or wherever. Beer had been available in stoneware bottles since the early nineteenth century, but this did not typically represent a large portion of a brewery's sales. Glass bottles became increasingly available in the 1880s, and as the bottling process became increasingly mechanized, it became increasingly cost efficient and attractive to brewers. Accordingly, Renner established a sizeable bottling works next to the brewery shortly after the turn of the century.

As it turned out, the gradual rise of bottled beer provided an opportunity for brewers like Renner to expand on the variety of beer styles and brands they produced. Prior to this, with nearly all beer being sold in saloons,

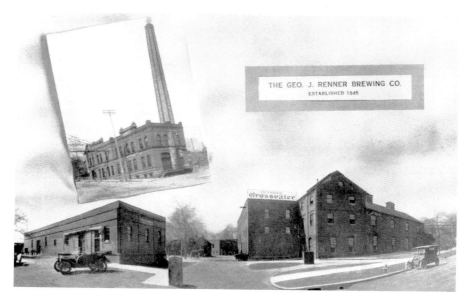

Renner brewery as it appeared in 1914; the inset shows the building across the street, which served as both a power plant and bottling plant.

the variety of beers produced by most brewers was very minimal, since the number of available taps in a saloon was often limited. This changed with bottled beer, since numerous brands could be produced and kept in a cooler for sale. By 1908, the company was producing Renner's Blue Label Beer, Yellow Band Lager, Renner's Extra Table Beer, Atlas Pilsner Export (later renamed as Eagle Pilsner Export) and bock beer for a limited time each year in the spring; each variety had slight differences in the recipe or brewing process to give a unique flavor. In 1912, a new name was introduced that would become the company's flagship brand for the remainder of its existence: Grossvater. The German word for grandfather, its label would often feature an older man or a group of older men enjoying the beer. As was the case with the earlier Eagle brand, Grossvater was also brewed at the Renner plants in Youngstown and Mansfield.

Along with the increased number of beer styles came a progressive need for Renner to advertise as a way to let the public know what varieties were available. Beer advertising had begun in the early days after the Civil War, although it generally consisted of little more than lithographed posters or calendars showing images of the brewery, pretty women or other eye-catching scenes. These would hang on the walls of saloons and provide a

general awareness of the brewery's name, although with most saloons of this era being owned by the breweries themselves, there generally was little competition for sales.

By the 1890s, however, improvements in transportation (mainly by rail) allowed breweries to extend their respective areas of distribution, and competition started to become an issue. Remarkably, brewers such as Pabst and Schlitz in Milwaukee and Anheuser-Busch and Lemp in St. Louis were able to sell their beers from coast to coast by the turn of the century, utilizing refrigerated rail cars and sending beer in large casks, where it would be bottled in local depots around the country. Foretelling the future of the brewing industry a half century later, advertising as early as 1900 encouraged the public to buy beer made in their local breweries instead of those in other states.

Opportunities to market beer were relatively few in the early days, with mass media being limited to newspapers. As a result, Renner advertised routinely in the *Akron Beacon Journal*, as well as the city's smaller papers, the annual city directory and playbills for local theaters. Still, most advertising took place at the point of sale: the saloon. Large tin signs emblazoned with the Renner name hung prominently outside saloons that sold the brand inside. After the turn of the century, advertising became more varied and creative. The company commissioned metal trays with ornate designs for use in saloons, while various ornate signs made of painted glass, tin, cardboard and wood hung on the walls. Even the company's bottle labels became more visually appealing as the years went by. On the more creative side, Renner commissioned local musicians to write sheet music for a waltz, named "Where the Grossvater Flows Everywhere." Intended to be played in saloons, its lyrics were written by Ernest Deibel. While overall beer advertising was fairly primitive by today's standards, it was still effective at getting the word out.

Renner's establishment of a separate ice business in 1895 was just the first of several side enterprises that appeared over the next few years. Renner and Deibel had begun to invest in local oil and gas wells by 1899, and their success in this growing field led to the incorporation five years later of the Renner-Deibel Oil & Gas Company. At the same time, the George J. Renner Property Company was established as a land development firm, as well as a way to manage the brewery's various saloon properties and other real estate ventures. Ultimately this company would outlive the brewery by many years.

All this time, Akron's population continued to grow, reaching 27,000 in 1890, 42,000 in 1900 and 69,000 in 1910. Renner prospered greatly from the

growth, with annual sales nearly doubling over that period; more than thirty-six thousand barrels were sold in 1915. However, the city's biggest growth was yet to come, as the rubber industry entered a period of explosive growth. With the city serving as the headquarters for Goodyear, Goodrich, Firestone and General, the nation's four largest tire companies (plus numerous other smaller companies and associated businesses), the city's population tripled during the 1910s, with nearly 210,000 people calling Akron home by 1920. Again, Renner was there to supply beer to the masses, with annual production reaching an all-time high of 65,000 barrels in 1917. Overall sales went from $300,000 (equivalent to more than $7 million today) in 1915 to $776,000 (nearly $19 million today) just two years later. However, the good times were about to come to an end.

As quickly as business had skyrocketed, it quickly came crashing back to earth over the next two years. The nation's temperance advocates, also known as the "dry" movement, had been working for many years to rid the country of saloons and alcohol, and America's entry into World War I gave them ammunition to quickly further their cause. A dramatic increase in beer taxes and limitations on the amount of available grain, both instituted in the name of the war movement but pushed heavily by the dry forces, made business much more difficult in 1918. Similarly, a law was passed reducing the allowable alcohol level in beer to 2.75 percent (previously, most beer had roughly 4 percent alcohol). By the time of the November 1918 elections, Ohio's residents had been convinced to vote in favor of outlawing saloons altogether, and alcohol sales became illegal the following May (eight months prior to the start of nationwide Prohibition). Renner, like all of Ohio's remaining brewers, was then forced to make dramatic changes to his business in order to protect its assets and its legacy.

THE M. BURKHARDT BREWING COMPANY

Another early enterprise that would rise to long-lasting prominence in the city was the Wolf Ledge Brewery on Grant Street. Although its exact date of establishment is debatable, the site on which it stood was known to have been purchased by native German Frederick Gaessler in 1865. Some sources indicate that Jacob Fornecker, a cooper by trade, had actually established the brewery two years earlier, but there is no hard evidence of this. Either way, the business was successfully producing ale and lager beer during the post–Civil War era, as the city's industrial boom was drawing fellow Germans into the city in large numbers.

The only brewery to operate in the heart of the city's German district, it was located along Wolf Creek in the Wolf Ledges area. Named for the scenic ravine with rock ledges that lined the creek, the site was popular with local residents for picnics, as well as supplying pure water for drinking and for the brewing process. As was the case with the Forge Street Brewery described earlier, this was an ideal site for the formation of a brewery. Although its original structures faced eastward, taking the address of 152–156 Sherman Street, later structures on the property faced westward, taking the address of 509–543 Grant Street.

By 1871, Gaessler had taken on fellow German Otto Giessen as a partner as production continued to increase, topping 2,700 barrels by 1875 and making it the city's most productive brewery. Around the same time, Giessen left the partnership to purchase a brewery on the outskirts of Canton, twenty-five miles south of Akron. After this new plant was destroyed by fire several

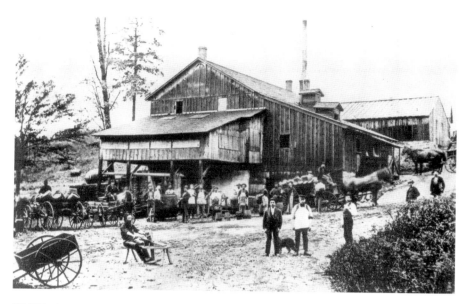

Wolf Ledge Brewery, circa 1878; in the foreground are Frederick Gaessler and Wilhelm Burkhardt. Jacob Fornecker is sitting at left, working at a *schnitzelbank*, or carving bench.

years later, Giessen rebuilt inside the city, establishing what would later become the foundation of the large Stark-Tuscarawas Brewing Company.

In Giessen's absence, Gaessler hired a new brewmaster by the name of Wilhelm Burkhardt, a decision that would ensure the company's success for the next eighty years. Born in 1849, Burkhardt was one of the most experienced brewers in early Akron, having attended a brewer's college in Germany before coming to America in 1868. He had worked for several years for a Cleveland firm before coming to Akron, where he became part owner of the Wolf Ledge Brewery (which was then renamed as Burkhardt & Company) in 1877.

Although production had dropped to fewer than two thousand barrels by 1878—due to a combination of factors that had led to a general depression in the brewing industry at the time—the company was still operating successfully as the decade's end approached. However, just as disaster had struck the Oberholtz Brewery across town six years earlier, the same thing happened to Burkhardt and Gaessler on the night of June 24, 1879, as the entire plant went up in flames. Beginning in a defective flue, the fire quickly spread throughout the brew house and most of the storage areas, all of which were still of wooden frame construction (not a good choice for a brewery).

The loss was valued at $4,000 but was mostly covered by insurance. Although Burkhardt made the decision to rebuild, beginning with what little was saved from the fire, Gaessler chose to exit the brewing business at the time, instead operating a saloon several blocks away for the next twenty years.

Burkhardt had learned his lesson the hard way, as the new buildings were made entirely of brick and stone. Rebuilding began immediately, and once completed in early 1880, the plant was considerably larger than its predecessor, putting it in a good position for future growth. However, more tragedy would strike the family just two years later, as Wilhelm Burkhardt died of "blood poisoning" (sepsis) on April 13, 1882, at the age of thirty-two. This followed the death of his two-year-old daughter, Carrie, due to encephalitis, by just five days.

While such personal losses were undoubtedly devastating to Burkhardt's widow, Margaretha, she refused to let them defeat her. The former Margaretha Wagemann had been born in 1848 in Krumbach, Germany, and married her husband in 1872 while he was working in Cleveland. Suddenly put in a position at the age of thirty-four where she had to oversee operation of a company in a highly male-dominated industry, while raising two young sons at the same time, she rose to the occasion and was able to guide it successfully for more than forty years. The company ran smoothly throughout the 1880s, with annual production reaching nearly five thousand barrels by 1889.

Another misfortune befell the brewery on May 10, 1890, when a large tornado roared through the Goosetown neighborhood, destroying many homes in its path. While the brick brewery structure was largely unharmed, several wooden sheds and an icehouse were destroyed, with damages estimated at $3,000. Although a fund was established by fellow Germans to help those whose homes had been damaged, Mrs. Burkhardt refused any help, as reported in the *Beacon Journal* several days after the storm: "Mrs. Burkhardt feels hurt by the heading of the subscription at the rolling mill and says that although she lost $3,000 by the damage to her brewery, she asks for no assistance from the relief fund, but is ready instead to draw her check for whatever amount the canvassing committee may call upon her for. The workmen, who made the repairs upon her property, offered to do their work without pay, but she would not consent to this, paying them the regular wages."

Over the next few decades, Margaretha's teenage sons began to take prominent roles in the brewery's operation. Gustav F. "Gus" Burkhardt was born in 1874 and attended Akron High School before studying at

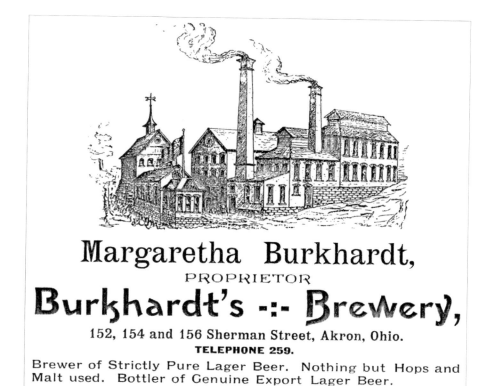

Margaretha Burkhardt,
PROPRIETOR
Burkhardt's -:- Brewery,
152, 154 and 156 Sherman Street, Akron, Ohio.
TELEPHONE 259.
Brewer of Strictly Pure Lager Beer. Nothing but Hops and Malt used. Bottler of Genuine Export Lager Beer.

Advertisement for the rebuilt Burkhardt brewery. *From the* 1892 Akron/Summit County Atlas.

Chicago's American Brewing Academy. After graduating in 1898 with the degree of master brewer, he began a long career with the brewery as its general manager. His brother, William L. Burkhardt, was born in 1877 and attended Buchtel College (prior to it becoming the University of Akron) before joining the brewery's office staff as a bill collector. The brothers and their descendants would ensure family ownership of the brewery for another half century.

By the turn of the century, the city's booming population created a rapidly growing demand for beer, far exceeding the relatively small plant's capacity. Recognizing the need to expand the brewery's output, Burkhardt took the first step by incorporating the brewery as the M. Burkhardt Brewing Company in 1902; capital stock of $50,000 brought in by new investors gave the company room to grow. Margaretha was the company's president, with

Gus serving as vice-president and William as secretary and treasurer. Martin Fritch, a recent immigrant from Germany, was hired around the same time to serve as the new brewmaster.

The project to expand the plant had begun in 1901 with the addition of a new ice facility capable of producing fifteen tons of ice per day for cooling the storage cellars. Soon after this came the addition of a large storage building. The project began to accelerate two years later with the erection of a six-story brew house, immediately west of the existing structures (this tall structure remains the most recognizable part of the brewery complex

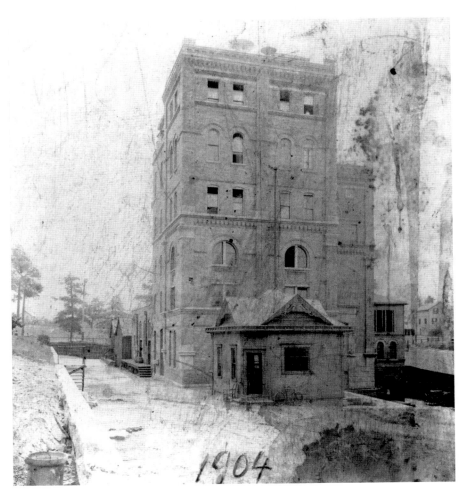

The recently built brew house for the Burkhardt brewery, as seen in 1904. *Tom Burkhardt Collection.*

today, well over a century later). This was followed by construction of a new stock house, racking room, wash house and boiler house. Over a five-year period, nearly every building in the plant was replaced by a newer and larger structure, and by 1908, its annual capacity had reached forty thousand barrels.

Burkhardt had established a small bottling works adjacent to the brewery in 1890, although bottled beer did not yet represent a large part of the company's business. Sales of bottled beer began to increase after the turn of the century, especially after the opening of The Akron Brewing Company several blocks away in 1903. Owned and operated by saloon owners, the new company quickly cut into the business of the city's established brewers, who then began turning more to the business of bottling to make themselves less dependent on draft sales in saloons. Business was aided to some extent by a typhoid fever scare in June 1904, making many residents afraid to drink local water. Burkhardt took out full-page advertisements in the *Beacon Journal* to assure the public that its

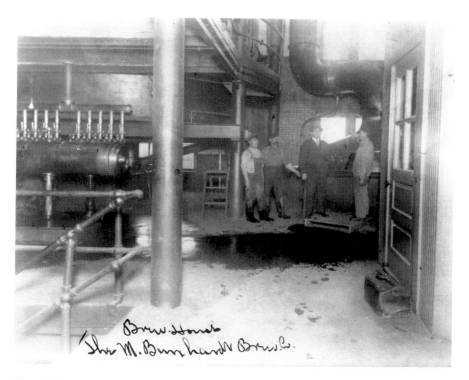

View inside the Burkhardt brew house, circa 1910, showing the brew kettle in the background. *Tom Burkhardt Collection.*

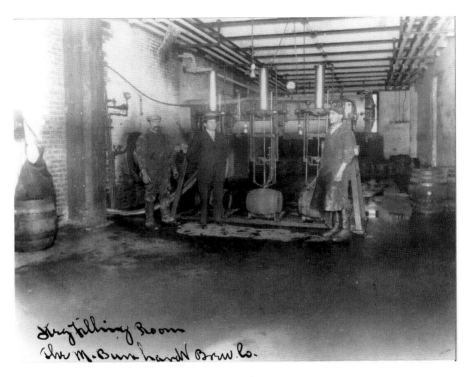

View inside the Burkhardt keg filling room, also known as the racking room, circa 1910. *Tom Burkhardt Collection.*

beer was safe to drink because it was brewed with pure spring water from on-site wells.

By 1908, Burkhardt was selling 2.2 million bottles of beer per year, a significant portion of its overall production, and as early as 1904 was known to use the phrase "King of All Bottled Beers" in its advertising (prior to Anheuser-Busch establishing a copyright for the slogan). In 1912, a new bottling plant was built just west of the brew house tower and facing Grant Street to facilitate this rapidly growing side of the business. Unlike some breweries of the era, which sold beer under multiple brand names, Burkhardt only bottled its beer as either Standard Lager or Select Export. Bock beer was also produced for several weeks in the spring, and in the years leading up to Prohibition, the company produced a non-alcoholic cereal beverage for sales in areas that had already voted themselves dry.

Aside from the typical signs, saloon trays and lithographed calendars that were used by most brewers in the era before electronic media

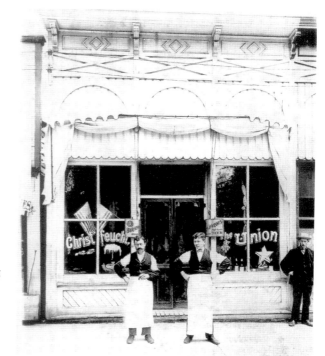

Right: The entrance to Christian Feucht's saloon in Akron, featuring Burkhardt's High Grade Beers, circa 1900.

Below: View inside the sterilizing and pasteurizing room at the end of the bottling line, circa 1910. Stacks of wooden crates, filled with bottles, are seen in the background. *Tom Burkhardt Collection.*

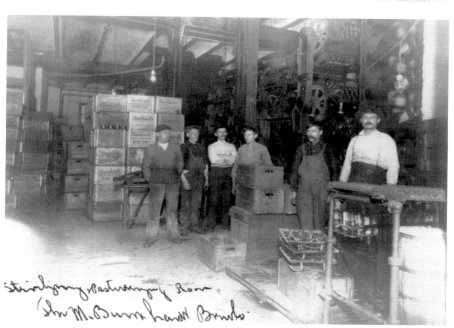

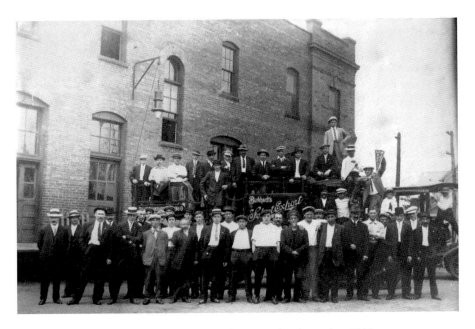

Burkhardt employees pose on a delivery truck next to the plant, circa 1910.

became available, Burkhardt's marketing consisted mostly of word of mouth, especially in the city's German community, and newspaper advertisements. The company began advertising in the *Akron Germania* (the city's German-language newspaper) in the early 1880s and then in the more widely distributed *Beacon Journal* after the turn of the century. Early advertisements were typically very simple and achieved little more than name recognition. Over time, they began to include more intricate images (one early series of ads featured characters known as the "Hop Twins") and, in some cases, lengthy sections of text.

This latter trend became particularly common during the 1910s, as the brewing industry attempted to educate the public about beer being a temperance beverage, entirely different than hard liquor, in an attempt to negate the more vocal Prohibitionists who saw no value in any form of alcohol. In the fall of 1910, Burkhardt ran a series of nine weekly essays in its advertising, explaining the nutritional and health-giving benefits of beer and explaining how drinking beer promotes sociability while preventing alcoholism. At the end of the series, readers were asked to submit their own essays about beer, with the three best entries receiving seventy-five dollars in gold (the country was still on the gold standard until 1933).

Other advertisements used humor or holiday cheer, all in the name of keeping the Burkhardt name in the public eye.

As the ice business continued to grow along with the brewery, Burkhardt established a wholly owned subsidiary business in 1907. Known as the City Ice & Coal Company, its officers were the same family members, and it maintained offices and a warehouse on South Broadway. In the same year, the Burkhardt Realty Company was founded primarily to manage the brewery's saloon properties, as well as developing some of the extensive real estate holdings that the family had accumulated over the years. This would eventually branch out into other side businesses and would outlive the brewing operation by many years. Two years later, at the age of sixty-one, Margaretha Burkhardt stepped down from her position as president, although she would remain a director for the rest of her life. Her son Gus became the company's president, with brother William as vice-president.

Seeing success with the ice company, Burkhardt expanded its ice production in 1912 by spending $30,000 to build a new ice facility as part of its new three-story stable and garage building on the south side of the complex. The large structure came complete with concrete horse heads over the entrance on Grant Street that remain intact today. The building's

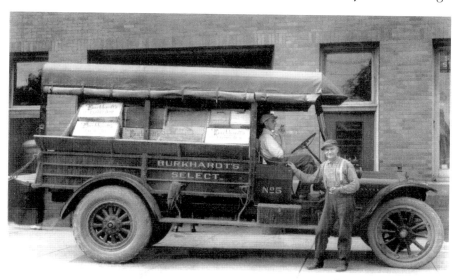

Burkhardt delivery truck loaded with wooden crates, circa 1915. *Tom Burkhardt Collection.*

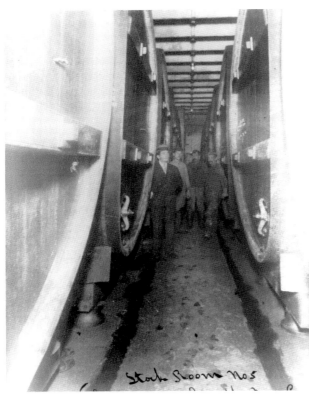

Left: View inside Burkhardt Stock Room no. 5, circa 1910, showing more giant aging tanks. *Tom Burkhardt Collection.*

Below: Burkhardt built this special float for a local parade, circa 1915, featuring bottles, kegs, signs and a huge promotional barrel. *Tom Burkhardt Collection.*

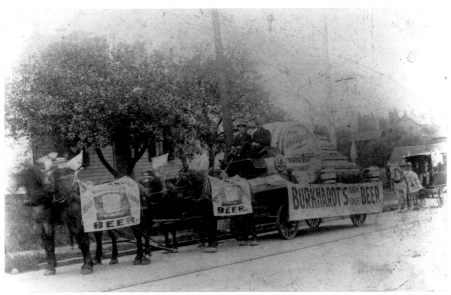

THREE GENERATIONS

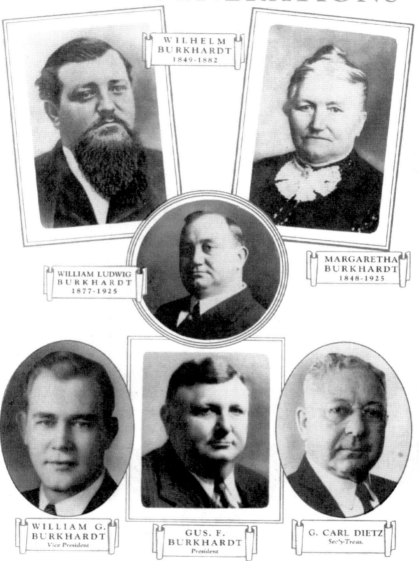

Burkhardt family tree, taken from a 1940 promotional brochure for the brewery. *Bill Carlisle Collection.*

Another variation of delivery truck used by Burkhardt, circa 1917.

construction required the permanent burial of Wolf Creek, which was routed through a large pipe below the building's foundation. A far larger investment was made four years later with the construction of a huge three-story bottling building on the north side of the complex. Costing $146,000, the new plant reflected the level of success Burkhardt was seeing with its bottled beers, but it also represented a significant gamble due to the increasing likelihood of Prohibition's arrival in the not-too-distant future. After the new plant was occupied, the smaller structure previously used for bottling was converted into the company's office building.

Also in 1916, Burkhardt sought to expand its name recognition by beginning a several-year sponsorship of a local professional football team. Formerly known as the Akron Indians, the team had formed in 1908 and had been relatively successful in the Ohio League, which was a direct predecessor to the National Football League. Renamed as the Akron Burkhardts, the team remained successful but lost money over the next two years, after which the Burkhardt sponsorship ended. Sold to a new owner in 1920, the team was renamed as the Akron Pros and won the first official championship of the American Professional Football Association (which became the National Football League in 1922). After this, however, the Pros gradually dwindled in popularity and financial support until being disbanded in 1927.

Despite the company's tremendous successes over the previous thirty years, it was forced to comply with statewide prohibition when it went into effect in May 1919. Like the city's other two breweries, Burkhardt was forced to quickly rearrange its entire business model to remain solvent as a company, and although it would suffer through some dark times during the next fourteen years, it would emerge in 1933 intact, with its best days yet ahead.

THE AKRON BREWING COMPANY

Over the last two decades of the nineteenth century, Akron's brewing industry and saloon trade had been dominated by the Burkhardt and Horix/Renner breweries. Soon after the arrival of the new century, however, a new player appeared on the scene, arriving with a 1904 version of a "media blitz" while representing two of the most common trends in the industry at the time. Prior to the 1880s, the vast majority of breweries had been established at the ground level by individuals or partnerships, typically first- or second-generation immigrants from Germany or England, and their companies gradually grew over time (assuming they were successful). Due to a number of factors, however, those days were gone by the turn of the century. By that time, established breweries were dominating their respective markets, making it more difficult for new and unknown brewers to establish themselves and make their beers available for sale in saloons (a problem many new craft brewers still have today).

In addition, the costs of doing business had been continually rising, another trend that continues to this day. The cost of brewing equipment alone had increased significantly, as brewing technology continued to make rapid strides forward. Gone were the days of the small, one-story facilities with small brew kettles; these had been replaced by large brick structures, often several stories in height. Part of this related to changes in the brewing process itself, as most brewers were now using gravity-based systems, allowing the various products in the brewing process to

drop from one level to the next, with the brew kettle itself generally on the lowest level. This decreased the cost of pumps needed to move the liquid from one phase to another. The other reason that brewing structures had changed so drastically was to make them relatively fireproof. As we saw with both the Horix and Burkhardt plants, fires were extraordinarily common in early breweries. Eliminating as much wood as possible from the construction and replacing that with iron beams and floors made of concrete and asphalt dramatically decreased this risk.

The introduction of mechanical ice production had also increased the startup costs for a brewery. While cutting ice from a pond or river was inexpensive, the concept was dependent on the weather and was generally outdated by 1900. The use of an ice machine was now a necessity, both for cooling the building for the brewing process and for ice production to augment revenue. Costs of grain and other materials used in the brewing process had risen as well, partly due to an increased understanding of the biology of brewing; several industry magazines were available on a monthly basis, with each issue explaining some of the different chemical reactions involved in brewing, interactions of different strains of yeast, qualities to look for in malt and other grains and more. Gone were the days when brewers could use grains from questionable sources, as the public was becoming more discerning with regard to flavor, carbonation and the finer points of beers. Brewing was quickly becoming more of a science and less of an art. The cost of labor, while still minimal by later standards, was starting to rise as well with the recent arrival of brewery workers' unions, although their effect on Akron's brewing industry was not yet a major issue.

As a result of these costs, the only practical way to enter the business was to form a corporation to attract investors, creating a sizeable pool of money in the form of capital stock. This money would be used to purchase property, hire an architect, build the new plant, install state-of-the-art equipment, purchase raw materials and market the finished product. A large number of these stock company breweries were established nationwide in the first decade of the twentieth century; while some were incorporations of previously existing brewing companies, many were entirely new companies that were entering the market for the first time. Looking at the officers of older preexisting breweries, the names were generally Germanic in nature, while the names associated with the newer breweries were just as likely to be of an Anglo-Saxon background, often made up of pure businessmen with no background in the brewing industry whatsoever.

HERE'S TO AKRON!

For Family Use no beer will excel our Bottled Beer. which will be ready for delivery in ten days.

It will be pleasant and delicious to the taste, full of nutriment and tonic qualities and absolutely pure.

A Visit to the Akron Brewery Co.'s New Plant

Will convince you of two things that are essential to expert brewing.

Guaranteed Purity Properly Aged

The beer is made of pure imported hops, pure barley malt and pure water. The steel cooperage of the tanks in our large cellars are the best evidences of its purity from a sanitary standpoint, and the enormous tank capacity of this modern structure will convince you that we are in a position to store our beer until it has been properly aged.

THE AKRON BREWING COMPANY'S
HIGH-GRADE LAGER BEER

IS NOW ON SALE AT ALL FIRST-CLASS BARS OF AKRON and vicinity. This Beer is made of the best hops and malt obtainable. It is brewed and aged by an expert brewer in a perfectly constructed brewery. It will be the delight of all beer drinkers. The plant of the Akron Brewing Company is a magnificent example of modern science in building and equipment. The public is invited to call and be shown.

THE AKRON BREWING CO. SOUTH HIGH STREET
BETWEEN VORIS AND SOUTH

Full-page announcement of the Akron Brewing Company's grand opening, from the *Akron Beacon Journal*, May 24, 1904.

Akron's first experience with a stock company brewery began in October 1902 with the establishment of The Akron Brewing Company, which was incorporated six months later with capital stock of $200,000 (just over $5 million today). Not only following the stock company trend, it also followed a less prominent trend of saloon owners opening their own breweries, something that was seen in other cities (including Cleveland and Canton) around the same time. For many years, a common complaint among Akron's saloonkeepers was that the cost of beer in general was too high (both from local breweries and those elsewhere), making it increasingly difficult to make a profit. In their eyes, operating their own brewery and controlling the supply end of the issue was the answer, guaranteeing the availability of beer and allowing them to maintain prices at a reasonable level, thereby allowing all to benefit.

The new brewery was thus created by a group of fifty Akron saloon owners, in addition to other businessmen who saw this as a potentially good investment. It was optimistically assumed at the time that most of the 176 saloons in the city of Akron and 250 saloons in Summit County would patronize the new establishment. However, it was claimed at the

time that since most of the saloon owners who were involved with the company dealt mostly in imported beers, the new brewery would not negatively affect other local brewers (Burkhardt and Renner) to any significant degree.

The driving force behind the company's formation was John Koerber, owner of the Bank Café in downtown Akron. He had previously been involved in the formation of other stock companies before coming to Akron in recent years, and after the new firm was in operation, he became its first president. Vice-president was our old friend Fred Horix, who had already operated two different breweries in the city and at the age of fifty-nine had more experience in the industry than anyone else in the group. Real estate agent John Lamparter was the company's treasurer, while beer distributor F. William Fuchs was secretary and general manager of the new plant.

Once the company was established on paper, $5,600 was spent to purchase property at 841–869 South High Street, just south of downtown

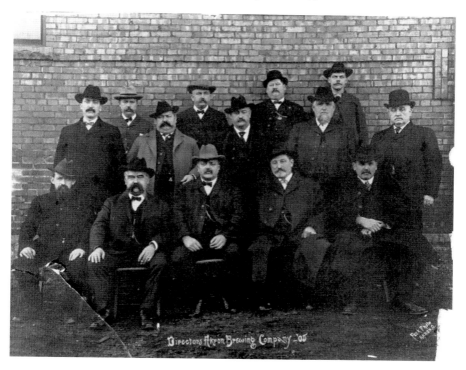

Directors of the Akron Brewing Company posing in front of the plant in 1905. In the second row, far left, is John Koerber, the company's founder. Next to him is Louis Dettling, who served as president for many years. Also in the second row, second from right, is former brewer turned saloon owner Fred Horix.

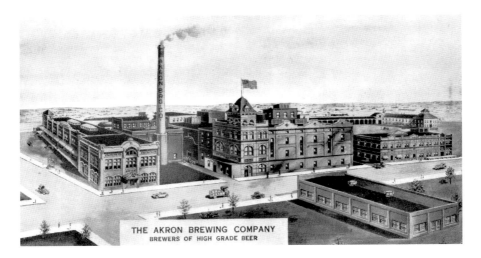

The Akron Brewing Company plant as it appeared in 1914. The offices and bottling plant are at far left, while the stables and machine shop are at far right. The brew house tower was obscured by a large brick wall when a new and larger brew house was built on the site of the smokestack in 1917.

(many years later, as traffic flow was rerouted, South High became South Broadway), and construction began on the new $150,000 facility with a groundbreaking ceremony on September 3, 1903. Designed by Detroit architect Richard Mildner, the ornate plant was completed several months later, stood five stories in height and had an annual capacity of thirty thousand barrels of beer.

The plant was made entirely of steel frame and brick, making it virtually fireproof, and the holding tanks were made of enameled steel, as compared with the older wooden vats that most existing breweries still used. The remainder of the plant included a large stock house for storing and aging beer, an ice plant, a boiler house, a bottling house and an extensive series of stables for horses to pull the delivery wagons throughout the city. Adjacent to the bottling house was a two-story office building, the basement of which contained an ornately decorated hospitality room where visitors could sample free beer (a commonly told rumor was that during the Prohibition era, this hospitality room was converted into a speakeasy, providing illegal beer and other spirits for those who could afford it and who knew a password to enter).

Although the company was operated by saloon owners, its sales were not limited to draft beer in the saloons. Bottled beer was becoming increasingly popular after the turn of the century, allowing one to purchase beer for use

at home or elsewhere and avoiding saloons altogether. By this time, saloons were viewed by some as the scourge of society, leading to crime, violence and other negative behaviors due to the alcohol served inside. This view was promoted heavily by the increasingly vocal temperance crusaders, who were intent on eliminating saloons, along with alcohol itself, from society (although it would take them another fifteen years to reach this goal).

Even before the entire plant was completed, brewmaster John Hau started the first brew on February 24, 1904. When it was completed, the first batch of White Rock Export Beer was made available on tap at area saloons on May 24; ten days later, it appeared in bottles as well. The brand's introduction was advertised heavily in the *Akron Beacon Journal*, with the company inviting the public to visit and tour the plant to see how clean and modern it was. Advertisements described White Rock variously as "a home beverage," "Akron's great summer beverage," "a revelation to every critical taste" and "fine in flavor and pleasantly exhilarating," along with similar terminology.

Over the next decade, the company also released a generic brand of lager beer, as well as Wurzburger dark beer. The company's sales were good from the start, largely due to the eighty-two saloons that were owned by its various shareholders; with roughly one-third of the county's saloons under

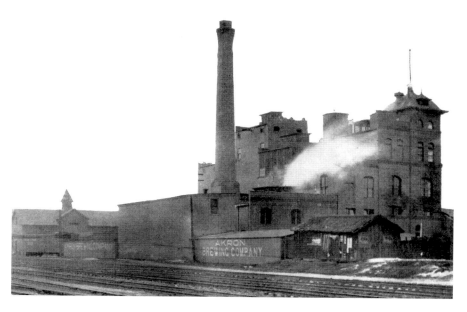

Rear view of the Akron Brewing Company, as seen from the railroad tracks, circa 1910.

Postcard view of the Biddie's Café and Bar in Akron, circa 1910, featuring beer from the Akron Brewing Company. *Don Augenstein Collection.*

its control, White Rock Beer was assured a prominent position in the local market. Like the city's other brewers, the company continued to advertise regularly in the *Beacon Journal*, as well as producing numerous signs made of tin, glass and wood; ornate lithographed calendars; and tin serving trays used in saloons, some with views of the brewery itself and some showing eye-catching images of women.

Timing is everything, and another factor that helped the new company, at least in its marketing, was the fact that Akron was in the midst of a typhoid fever scare in the summer of 1904. Although some residents avoided all beverages made with local water, the company stressed that its water source was a deep artesian well, not city water. In addition, the boiling involved in the brewing process and the presence of alcohol in the beer also had a protective effect for consumers, making beer a preferable beverage over water or soft drinks made with water.

Another common trend in the industry came into play in late 1905 when a proposal was made to combine the Akron, Burkhardt and Renner breweries into one large corporation. Inspired by similar actions in the oil and steel industries over the preceding decade, the formation of brewing combines had already taken place in Cleveland, Canton, Columbus, Dayton, Toledo and Pittsburgh, and it seemed logical that Akron should join that group.

The benefit of forming a combine was to operate more efficiently, saving money on raw materials, distribution and marketing, while eliminating older or inefficient plants and maximizing profits in the process. However, in the end, the stockholders of Akron Brewing voted against joining the combine, thereby killing the proposal.

John Koerber left the company just two years after its inception, moving with his wife and seven children to Ionia, Michigan, where he purchased a small brewery that had recently burned. Although he was able to rebuild it successfully, the business collapsed in 1909 when local residents voted to make the county dry. Ruined financially, Koerber died just two years later of Bright's disease (kidney failure caused by high blood pressure). His sons remained in the brewing business, however, and operated breweries in Ionia and Port Huron, Michigan, as well as Toledo, Ohio, for fifteen years after Prohibition's end.

In Koerber's absence, the Dettling brothers took a prominent role in the company's management. The proprietor of the Rathskeller, a prominent restaurant and tavern in the heart of downtown (located at the site where the Cascade Plaza now stands), Louis Dettling had been an original investor in the company along with his brothers Jacob and John (also saloon proprietors), and

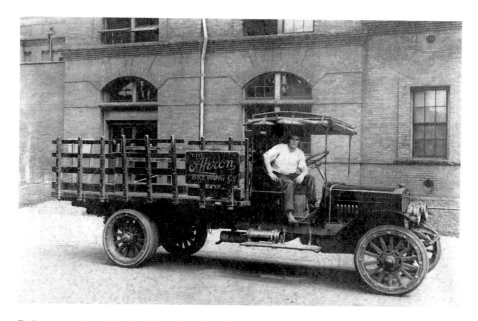

Delivery truck used by the Akron Brewing Company, in front of the entrance to the brew house, circa 1915.

Louis would succeed Koerber as president, remaining in that position until his death in 1917. Jacob Dettling succeeded him as president, leading into the Prohibition era. In the meantime, brewmaster John Hau was succeeded in that position by Ernst Hafenbrack and, later, by Walter Gruner.

By 1916, the company's success had led its directors to defy conventional wisdom and invest heavily in a major expansion of the plant over the next year. The capital for this new construction came from the stockholders, as capital stock was increased to $400,000. The strategy was risky, however, in that statewide Prohibition had been on the ballot every year, slowly gaining votes and drawing the state closer to going dry, at which point such investments would become worthless. The $45,000 expansion consisted of an entirely new, four-story brew house that towered over the rest of the plant, while the original ornate brew house was converted into more storage space and obscured with a huge brick façade.

From an architectural perspective, the new building was notable in its absence of Victorian or Romanesque Revival features, which had been present in many breweries built around the turn of the century or before. As a description in the *Western Brewer* trade magazine noted, "The architect has endeavored to get away from the usually flashy and showy style of brewery architecture with numerous towers, parapets, and other gingerbread ornamentation, and has succeeded in designing a building whose strong lines and absence of unimportant details will class it among the best-designed industrial buildings of its kind in the country. The simple, yet strong and pleasing exterior of the stock house is a model of brewery architecture."

New equipment was installed, including a 400-barrel brew kettle, which enlarged the plant's annual capacity to 100,000 barrels. The interior walls of the new building were lined with white enameled brick, which was easy to clean, leaving a sanitary environment for brewing. Other improvements took place as well, giving the plant the appearance that it would have for the next century, as a major landmark on the city's south side.

As with the city's other brewers, the days of success came to a crashing end in May 1919 with the arrival of statewide prohibition, put into effect by the state's voters in the November 1918 election. With the company's primary source of revenue wiped out overnight, it was forced to find alternate ways to utilize the huge plant and continue to do business. The first step was to reorganize as the Akron Beverage and Cold Storage Company, with capital stock raised to $500,000 to cover the costs of renovating the facility. The refrigerated aging cellars were ideal for cold storage of a wide variety of foods and other products.

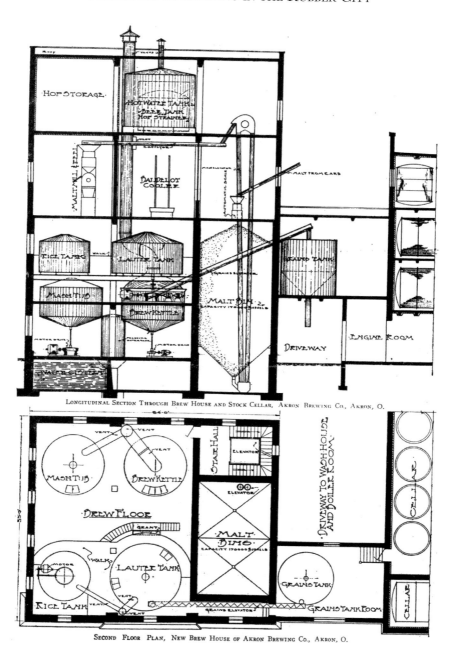

LONGITUDINAL SECTION THROUGH BREW HOUSE AND STOCK CELLAR, AKRON BREWING CO., AKRON, O.

SECOND FLOOR PLAN, NEW BREW HOUSE OF AKRON BREWING CO., AKRON, O.

Cross-sectional view, looking eastward, of the new brew house built for the Akron Brewing Company in 1917. *From the* Western Brewer.

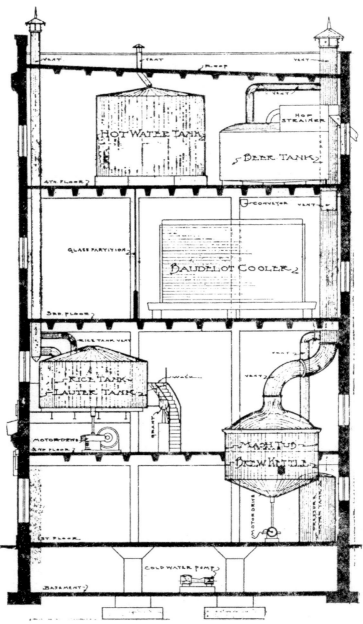

CROSS SECTION THROUGH BREW HOUSE, AKRON BRG. CO.

Cross-sectional view, looking northward, of the new brew house built for the Akron Brewing Company in 1917. *From the* Western Brewer.

While the White Rock brand name was retained, it was now brewed as a non-alcoholic cereal beverage. A similar beverage named Tiro had been introduced in the spring of 1918 for sales in areas that were already dry, but it was not marketed heavily. While the name was a clever tribute to the city's stature as the Rubber Capital of the World, with the letters in the logo shaped like tires, the name was perhaps not ideal for a beverage. Tiro disappeared from the market without a trace within a few months. White Rock Cereal Beverage had the advantage of an established name, which it was hoped would propel the brand to success. Unfortunately, this was not the case, with the overall market for cereal beverages being relatively poor, and beverage production came to an end in 1924.

In addition to beverages and cold storage, the company formed an offshoot division, known as the White Rock Dairy, located in the former bottling works. Producing a wide variety of dairy products, this would turn out to be the most successful branch of the company. Another related division, the Diamond Land and Improvement Company, was owned by the stockholders. Formed in 1913, it oversaw management of the company's many saloon properties, which were either closed or renovated for new businesses in 1919. It had also accumulated a number of non-saloon properties over the years.

A long-standing legal battle between the brewery and Wisconsin's White Rock Mineral Water Company was rekindled during this period. Some years earlier, after the mineral water company filed a claim of trademark infringement, the brewery had won the right to use the White Rock name for its beer, which was not felt to be in direct competition with the bottled water. However, now that White Rock was technically considered to be a soft drink, and because the Wisconsin company also produced its own line of soft drinks, the feud erupted again. After a lengthy series of legal maneuvers, a federal judge ruled in 1924 in favor of the brewery, which was allowed to keep the name. Ironically, by this time the beverage business was essentially finished, as the dairy operation merged with the Peoples Dairy Company several months later, with operations being transferred to a new site on Bellows Street.

After the remaining brewing equipment was liquidated, the huge plant remained empty for a short time before the office building and dairy site were occupied by the Tasty Pure Food Company, manufacturers of Sumner's Butter and other products. Formed in 1923, the company remained at the location until being forced to vacate in early 2016. Much of the remaining plant was occupied for many years by a new and unrelated cold storage company, but by the 1980s, that was gone and the complex was home to

The Akron Brewing Company plant as it appeared in early 2016, shortly before demolition.

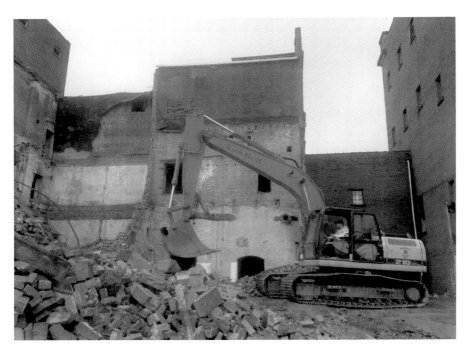

Demolition of the brewery complex took place over several weeks in the spring of 2016. Nothing remains at the site today, as it has become a construction zone for a new highway segment.

Glass sign used to advertise Renner's Crystal Ice in the 1890s; images of children were often used in advertising during this era, even for beer.

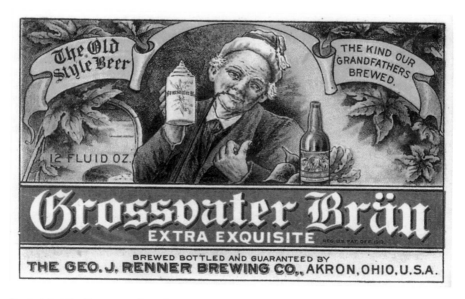

Bottle label for Grossvater Bräu Beer, circa 1913.

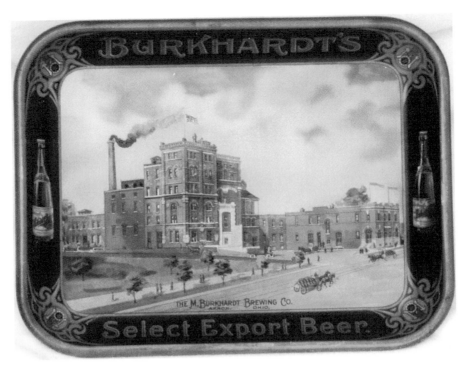

Serving tray showing the Burkhardt brewery as it appeared circa 1908.

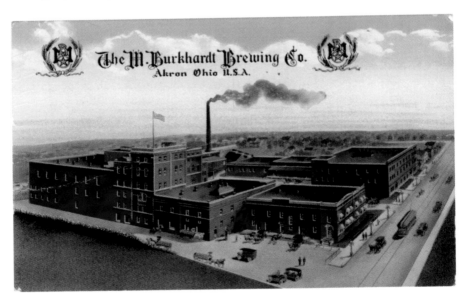

Postcard view of the Burkhardt Brewery, facing Grant Street, circa 1915. One year later, a huge bottling plant was built in the foreground, on the north side of the complex. All of these buildings remain standing today.

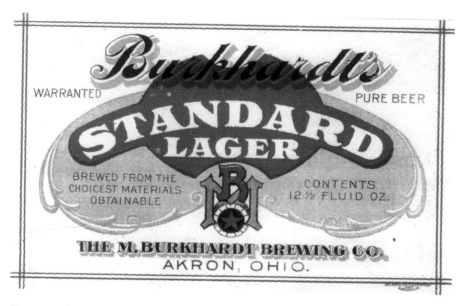

Rare paper bottle label for Burkhardt's Standard Lager, circa 1915. *Bob Kay Collection.*

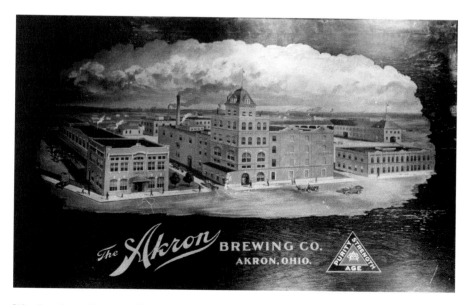

Wooden sign with a metallic foil decal, made by the Meyercord Company circa 1910. A large number of these survived Prohibition and are prized by collectors today.

Ornate bottle label of White Rock Beer, made in 1915.

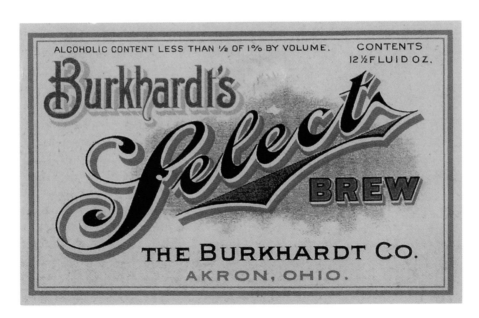

Bottle label for Burkhardt's Select Brew, a non-alcoholic version of its popular beer, circa 1920. The non-alcoholic version was significantly less popular, leading to its discontinuation after several years.

Bottle label for Orange Dee-light fruit drink, bottled by the Burkhardt Company, circa 1921.

Serving tray featuring Zepp malt beverage, another non-alcoholic choice from Renner, circa 1930.

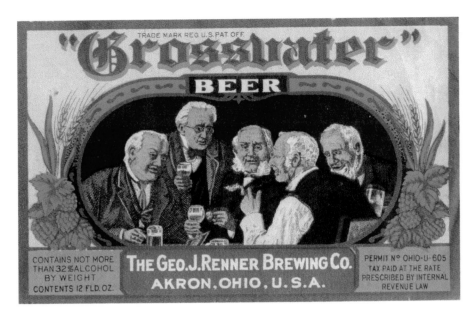

Grossvater Beer returned with a great splash of advertising in April 1933, although all of the beer sold that year contained only 3.2 percent alcohol. This bottle label makes that clear.

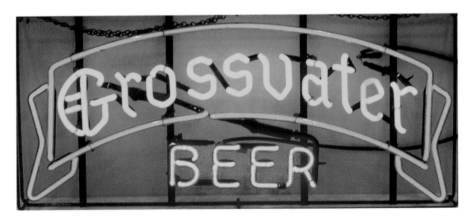

Neon sign for Grossvater Beer, circa 1940. Very few of these have survived and are in the hands of collectors today.

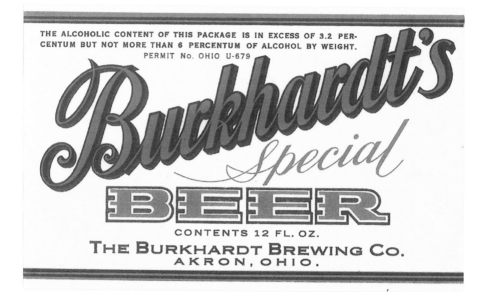

THE ALCOHOLIC CONTENT OF THIS PACKAGE IS IN EXCESS OF 3.2 PER-
CENTUM BUT NOT MORE THAN 6 PERCENTUM OF ALCOHOL BY WEIGHT.
PERMIT No. OHIO U-679

Burkhardt's
Special
BEER

CONTENTS 12 FL. OZ.
THE BURKHARDT BREWING CO.
AKRON, OHIO.

Burkhardt's beer also returned after Prohibition's end, but not until December 1933. By that time, full-strength beer (up to 6 percent alcohol) had been legalized, as shown on this label.

Large neon and lighted glass sign used by the Akron Brewing Company in 1934.

Above: Bottle label, circa 1940, for White Crown Cream Ale, a popular beverage in the region in the prewar era.

Left: Renner's Souvenir Beer appeared in these cap-sealed "Crowntainer" cans for several years in the early postwar period.

Right: After being largely forgotten and nearly discontinued during World War II due to its Germanic brand name, Grossvater Beer was reformulated in 1948 and received a completely new label in an attempt to boost Renner's declining sales.

Below: First appearing in 1938, Mug Ale was an English style of nut brown ale that maintained a healthy following for many years, remaining in production well into the 1960s.

Grossvater

Brewed from the Choicest Grains and the

Finest Domestic and Imported Hops Fully Aged

Special BEER

mug ale

IN EXCESS 3.2% NOT MORE THAN 7% ALCOHOL BY WT.

the BURKHARDT BREWING CO.
AKRON · OHIO.

CONTENTS 12 FLUID OZ. INTERNAL REVENUE TAX PAID

Above: In 1952, Burkhardt completely changed its label to a more eye-catching design. One year later, it bought a new canning line for flat-topped cans, as the cone-topped variety was gradually being phased out of the industry.

Right: The Burger Brewing Company operated the former Burkhardt plant from 1956 to 1964. Around 1960, it investigated using this experimental all-aluminum can, although the can was never put into actual production.

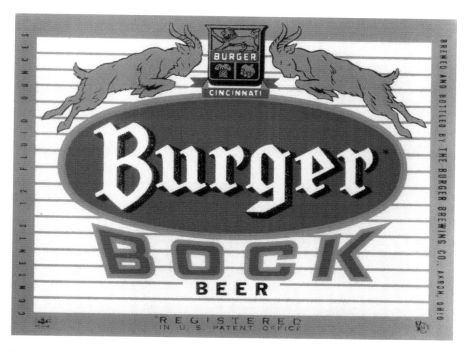

Burger beer, bock beer and ale were produced in the Akron plant. This bock beer label, circa 1958, was used each year for several weeks in March and April.

Thirsty Dog's modern bottling system.

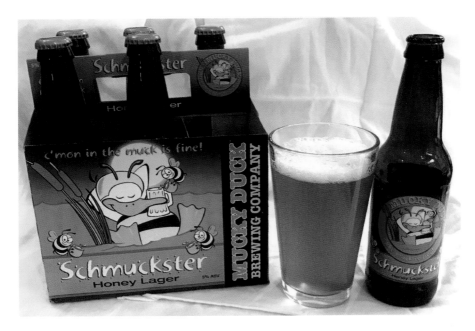

Mucky Duck bottles several of its brands and sells them in selected local grocery stores.

Like several other brewpubs in the area, the brewing system at Mucky Duck stands behind the bar, in full view of patrons. *Courtesy of Mucky Duck Brewing Company.*

Left: These ornate neon signs used by Thirsty Dog are appearing in more and more retail stores, not just in Akron but also throughout northern Ohio and in other states.

Below: The Thirsty Dog entrance on Grant Street is marked by a brew kettle, with the former Burkhardt Brewing Company office building in the background.

Right: Burkhardt's Mug Ale was a popular brand in Akron for more than twenty-five years, and neon signs like this one were seen in the windows of many area bars in the 1940s and 1950s.

Below: Owned and operated by Ali and Jon Hovan, the HiHo Brewing Company opened in Cuyahoga Falls in January 2017 with a large variety of craft beers on tap. *Courtesy of Ali Hovan.*

Above: Occupying a former car showroom on Front Street, the spacious HiHo Brewing taproom overlooks the Cuyahoga River gorge. The pub has quickly gained a large following. *Courtesy of Ali Hovan.*

Left: After operating on a small scale for three years, Madcap Brewing moved in 2016 to a large space on Mogadore Road in Kent, where it uses a ten-barrel brewing system. *Courtesy of Vince Rinaldo.*

Above: The Madcap taproom has a variety of entertainments—pinball machines, card games, Skee-Ball or just people watching—to enjoy while drinking any of the variety of beers on tap. *Courtesy of Vince Rinaldo.*

Left: Madcap has eight beers on tap at any given time, with unique names such as Major Blunder, Wizard Fist, World Up My Mash, Bad Leroy Brown Ale and 20 Eyes. GoldFlash Ale is named after the nearby Kent State University Golden Flashes sports teams. *Courtesy of Vince Rinaldo.*

various smaller companies over the next thirty years. In the meantime, the stables and other smaller buildings on the south side of the complex had been razed in the 1950s for construction of Interstates 76 and 77, which traveled within a few feet of the former stock house. This delicate balance continued for more than fifty years, until the Ohio Department of Transportation released plans for a $96 million project to rebuild the highway and its approaches in that part of the city, putting a target on the old brewery.

Finally, in the spring of 2016, the process of dismantling the entire complex began. Several days before the actual demolition started, the large stone letters atop the cellar building, spelling out "The Akron Brewing Co.," were carefully removed for preservation, overseen by Thirsty Dog Brewing Company's owner and history enthusiast John Najeway. Similar letters over the front door, spelling out "Brewhouse," were also removed. As thousands of Akronites were familiar with the building due to its prominent position along a major highway, it was painful for many to watch the gradual demolition process, which took place over the next several months and ended with the razing of the office building. The site is now part of the large highway construction project at the time of this writing. Aside from a new brick walkway in the author's backyard, nothing remains of the historic complex today.

THE DRY YEARS

Although Prohibition took effect in Ohio in 1919, it was the culmination of a series of events that had begun more than a century earlier. Alcohol had played a significant role in the lives of most adult Americans from the early settlers onward, and by the early nineteenth century, the average person was drinking the equivalent of several gallons of hard liquor each year. Around the same time, the first temperance societies were established along the East Coast, aimed at reducing the amount of alcohol consumed. Often started by local religious leaders, these movements began in response to crime and other negative behaviors associated with drunkenness, as well as a fear that religion was taking a back seat to alcohol for some members of society. The movement had strengthened by the 1840s, with more of a focus on total elimination of alcohol. In 1851, Maine became the first of several states (including Ohio) to enact laws prohibiting the sale of "intoxicating liquors," although most of them were later found to be unconstitutional.

In Ohio's early days, the activity of temperance groups varied widely from one region to another. In Summit County, the *Cascade Roarer* was a temperance newspaper that first appeared in 1844, quickly gaining 2,500 subscribers. Its editor was Sam Lane, a staunch prohibitionist who had a great deal of influence in the city, serving as newspaper editor, sheriff and mayor at different times. Over the following decade, a sense of fanaticism and extremism overcame some temperance advocates, many of them women. One such group's activities were detailed years

later by Sam Lane in his landmark book *Fifty Years and Over of Akron and Summit County*.

One morning in March 1858, a large group of women in Cuyahoga Falls visited a series of saloon owners wielding hammers, axes, hatchets and other weapons of destruction. The alcohol supply at each site was dumped into the river, with the exception of a few proprietors who had prepared for the visits by previously removing their whiskey, beer and more to another location. Despite the illegal nature of their acts, the women were publicly praised and suffered no meaningful legal punishment. The activities of these vigilantes were not alone, as similar attacks were carried out elsewhere. Years later, Carry Nation made such displays famous by traveling from town to town with hatchet in hand, threatening saloon owners on a regular basis.

The Prohibition movement might well have advanced more quickly if not for the Civil War, which put a damper on such activities for more than a decade. However, by the mid-1870s, the temperance advocates were again trying to bring the issue to the forefront. One group of crusaders consisted of "society women" who would travel through the city, kneeling and praying in front of saloons, breweries or any establishment that was thought to contribute to the alcohol problem. While these and similar groups attracted attention and headlines, they had little long-term effect. The first group to have any political clout was the Woman's Christian Temperance Union (WCTU), formed in Cleveland by Frances Willard in 1874. However, the first group to aggressively pursue legislative change on a national level was the Anti-Saloon League (ASL), formed in 1893 by Ohioan Wayne Wheeler. Wheeler was a master of political manipulation, and he began a two-decade campaign to sway the public to the temperance cause, while intimidating and threatening politicians who did not support it.

In 1907, Wheeler's first major success in Ohio was the passage of the Aiken Bill, raising annual saloon license fees from $350 to $1,000 (equivalent to nearly $25,000 today). For small saloon owners, this change was crippling, forcing them to close or lay off staff. One year later came passage of the Rose Law, allowing entire counties to vote themselves dry through a process known as local option. In the fall election of that year, fifty-seven of eighty-eight counties in Ohio proceeded to vote themselves dry, although large industrial counties such as Summit and Cuyahoga were not among them. While most of the counties that had voted dry reversed that decision three years later, the political power of the ASL continued to grow. The prohibition issue was placed on the statewide ballot every year, and even though the issue was consistently voted down, the margin was gradually shrinking.

The country's entry into World War I in 1917 was a blessing for the ASL and the WCTU, as it gave them new ammunition in their ongoing battles. Moral issues at home aside, the prevailing argument now was that using grains to make beer and other liquors hampered the war effort—instead they should be used to feed troops overseas to prevent them from starving. Also present was a festering anti-German sentiment that had been in place since the war had started in Europe three years earlier. With most breweries (especially in Ohio) still owned by first-, second- or third-generation German families, the brewing industry suffered further by association.

The statewide prohibition vote, which had lost by a wide margin in 1914, lost by only 1,100 votes in 1917. In November 1918, the once unthinkable came to pass as Ohio voted itself dry, one year ahead of the rest of the country. Production of all alcoholic products came to an end the following month, as all beverages were obligated to contain no more than 0.5 percent alcohol by volume. Alcohol could still be sold and served until May 26, 1919, after which the state was officially dry (joining neighboring West Virginia, which had gone dry five years earlier). The Eighteenth Amendment to the Constitution, the intention of which was carried out by the associated Volstead Act (also known as the National Prohibition Act), went into effect on January 17, 1920, making the entire United States a dry nation.

Renner was Akron's first brewer to deal with the problem in a meaningful way. Even before state prohibition took effect in May 1919, the company had begun bottling a dealcoholized version of Grossvater Beer. The company's marketing stressed that this was beer produced in the normal manner, from which the alcohol was extracted by a special vacuum process that was different than that used by other area breweries. This was a significant difference, as various methods were used for dealcoholization and Renner's "cousin" brewery in Youngstown used a heat-based system that left its brew with a notoriously burnt taste. Needless to say, sales of its RENO near beer were dismal, and its production was discontinued quickly.

Renner in Akron also made a crucial decision by maintaining its Grossvater brand as a near beer, as compared to most brewers who devised new brand names (many ending in the letter O to indicate the lack of alcohol) for their near beers. While some saw the Prohibition era as a new start, most recognized immediately that the public would not respond favorably to the non-alcoholic cereal beverages; realistically, they did not want to tarnish their established brand names on the chance that they would be able to use them again in the future if beer was relegalized.

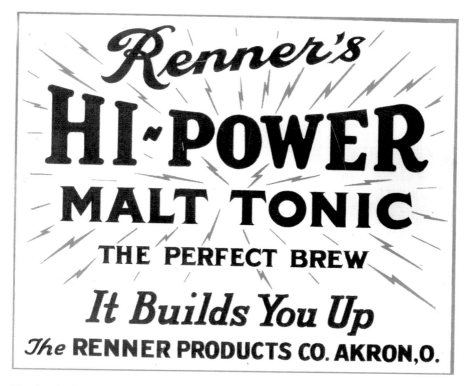

Tin sign for Renner's Hi-Power Malt Tonic, one of several non-alcoholic cereal beverages ("near beers") made by the company during the Prohibition era.

Renner, however, was willing to take the chance of using its Grossvater brand for a "near beer," and ultimately the decision paid off for the company, with the brand remaining in production throughout the Prohibition era. Grossvater was marketed heavily with extensive newspaper advertising combined with signs, trays and more to keep the brand in the public eye. In 1924, a second brand of near beer was released with a slightly different recipe. Known initially as Zeppelin but shortened ten days later to Zepp, it was produced to commemorate the local construction of giant airships by the Goodyear-Zeppelin Corporation. A third cereal beverage, known as Stuttgart, was introduced in 1928, although advertising for this brand was nearly nonexistent. These were later joined by a malt syrup known as Old Gross and a nameless hop-flavored malt beverage tonic, sold as a "liquid food." The label of the latter stated, "Recommended by physicians that this malt tonic is beneficial. A pure liquid malt and hop tonic that is food for the convalescent. A great health and strength giver. A blood and muscle builder.

Gives strength to nursing mothers. Not to be used for intoxicating purposes. Shake well before using." Renner also produced a "High Power" malt tonic around the same time, although it is unclear what qualified it as high power. Soft drinks such as Renner's Supreme Root Beer were produced as well. In addition to beverages, the company also produced distilled water and industrial-grade alcohol.

Renner had reorganized in 1919 as the Renner Products Company, with capital stock of $300,000. Meanwhile, the related realty company and the oil and gas company continued to operate successfully, unaffected by the Prohibition laws. Just two years later, company founder and namesake George J. Renner died of pneumonia at the age of eighty-five. After this, Ernest Deibel succeeded him as the company's president; with nearly thirty years of service to the company, he had been managing it on a daily basis for some time and was in a good position to navigate it through Prohibition's treacherous waters. Meanwhile, Nora and William Renner, both having a similar tenure with the company, remained in their supportive positions until their deaths in 1930 and 1932, respectively.

The related Renner breweries in Youngstown and Mansfield did not fare as well as the Akron company during this period. With RENO beverage being largely rejected by the public, it was discontinued in 1921, and the Youngstown company survived on revenue from its real estate management, ice production and a small amount of soft drink production. The Renner Brewery in Mansfield produced Red Band Cereal Beverage for a short time before shutting down its brew house altogether. It then survived on ice and soft drink production, as well as acting as a distribution point for the far more successful cereal beverages being produced at the Akron plant.

Overall, Renner's production ranged between ten thousand and sixteen thousand barrels per year during Prohibition, with sales of $146,000 being reported in 1921. One brew was made per week during the hotter months (when demand was higher), and one brew was made per month during the colder months. The bottling equipment, previously used on a full-time basis, was only in use for one half day per week. While these numbers represented only about 20 percent of the pre-Prohibition production, they were still dramatically better than most breweries in the state. Some of these had seen near beer sales drop to fewer than one thousand barrels per year before discontinuing production altogether. While Renner's beverage revenue alone would not have been adequate to keep the company in business, its diversification with other related businesses allowed it to remain solvent. In addition, the fact that the Renner brew house had remained

active while that of Akron's other breweries (and most of Cleveland's) had been dismantled left the company in a strong position to capitalize on Prohibition's end in 1933.

Across town, Burkhardt began the Prohibition era in a similar situation as Renner, but its fortunes would go in a somewhat different direction. Reorganizing as the Burkhardt Products Company in early 1919, the brewery continued to brew its Select Export Beer but also added its own process at the end to comply with the new laws by removing the alcohol, calling the result "Select Beverage." In addition, the company began producing an entire line of soft drinks such as Burkhardt's Ginger Ale, Root Beer, Parfay and Orange Dee-Light. By the mid-1920s, however, Burkhardt had withdrawn its own brands as it gained contracts to bottle national brands such as Hires Root Beer, Whiz Grape Soda, Whistle Orange Drink, Our Club Ginger Ale and White Rock Mineral Water. Select Beverage later gave way to Old Tavern Brew, a similar cereal beverage that was distributed over a wide area by an independent company. Ice production continued in conjunction with the City Ice & Coal Company, which remained successful.

In 1923, the family established the Burkhardt Consolidated Company, which oversaw operation of the realty company, beverage production and City Ice & Coal. However, in September 1925, William Burkhardt died after surgery, at the age of forty-eight. Two months later, Margaretha Burkhardt, the family matriarch and the lady who had built the company into what it was, died at the age of seventy-seven. In their absence, Gus continued as president, with Jacob Gayer taking the place of vice-president and Carl Dietz serving as secretary and treasurer.

Beverage sales had gradually dwindled over the years, as the public's general distaste for cereal beverages had not changed significantly. While brewmaster Martin Fritch remained with the company, his nephew Jacob Paquin, who had come to America from Alsace-Lorraine in 1907 to work with his uncle, found little work to do with the brewery. In 1925, he left to establish the Norka (Akron spelled backward) Beverage Company on Spicer Street. This company would remain in business, producing a variety of flavored sodas, until the 1960s; in recent years, the name has been resurrected by a new company that bottles the brand for local distribution.

By 1930, Burkhardt found that the overhead of maintaining its huge plant had become excessive in light of its poor beverage sales, and in that year, all beverage production ended, as the plant was closed and temporarily vacated. A small unrelated firm, the Akron Malt Products Company, occupied a portion of the plant for the next several years. Burkhardt's offices moved

The Burkhardt Consolidated Company offered a variety of non-alcoholic beverages during Prohibition, as shown in this 1927 advertisement from the *Akron Beacon Journal*.

to a new location at 918 Brown Street, as its officers hoped against hope that beer would someday become legal again.

As described in the previous chapter, The Akron Brewing Company reorganized in 1919 and survived on cold storage, dairy products and soft drink production before succumbing to economic reality in 1924. This was more typical of breweries throughout Ohio, as well as the nation as a whole. Prohibition decimated the industry, with the vast majority of breweries closing either immediately or after a death spiral of several years. While some breweries did return to operation after Prohibition ended, many of those were doing business with new owners and management. As brewery buildings were constructed around the unique features of the brewing process, they were often very difficult to repurpose for other industries, and as a result, many stood empty, a quiet symbol of happier times. The nation's skylines were littered with these towering buildings, their ornate Victorian or Romanesque architectural features slowly deteriorating over the years until meeting their end with a wrecking ball.

Overall, Prohibition was a colossal failure on every level. Bootlegging flourished, with liquor coming into the country from Canada, Mexico, the Caribbean and elsewhere. Speakeasies existed in every city, allowing those with a password or other connections to get beer and stronger spirits unabated. Many garages and basements had stills and small-time brewing equipment for home use, although the quality and safety of the beverages made there was questionable at best; some concoctions were downright poisonous. While enforcement of Prohibition laws was attempted, federal agents were poorly paid and were often easily bribed to look the other way. Political corruption was commonplace, both locally and nationally, with a great deal of money to be made by those who

bent the laws to their favor. As a result, there was a dramatic increase in organized crime during the era, particularly in larger cities such as New York, Chicago and Cleveland.

Enforcement of Prohibition laws was typically aimed at small-time brewers and moonshiners who couldn't afford to bribe their way out of trouble, while large-scale operations went undisturbed. An Akron woman appeared in court in 1927 to defend her husband, who was accused of illegal home brewing. As was reported in the *Beacon Journal*, the woman testified that her husband was acting on her behalf because Akron's city water made her sick. The judge disagreed, stating that the city's water was "the best in the country." Asked why she couldn't drink coffee instead, she claimed that it made her sick as well. The judge still found her husband guilty and fined him $100 plus court costs.

Another illustration of questionable law enforcement took place in Canton in the early 1930s. Otto Weber had been a legitimate brewmaster for one of the city's large breweries prior to Prohibition's onset and had lost his job as a result. Not one to waste his skills, he began brewing beer in his basement at home, assisted by his wife. They would work late into the night, brewing and filling bottles, one hundred cases at a time, and distributing them in the family car to speakeasies and social clubs, many of which were frequented by public officials, police and more.

One night, he was making deliveries when he was involved in a minor accident. When the police arrived, they saw his illicit cargo but opted not to mention it. He was only asked if he could drive the car. When the answer was yes, he was told to leave as quickly as possible, since the police knew that their beer supply would disappear if he were turned over to Prohibition agents. In relating the story years later, Otto's son, Wilbur, stated, "It was part of life. We didn't think too much about it being illegal. At $2.00 per case, each batch of beer brewed meant $200 in spending money, and that really came in handy during the Depression, when food stamps were the alternative." Otto Weber returned to legitimate brewing several years later, working as the brewmaster for the Canton Brewing Company.

Even the Volstead Act itself was full of loopholes that allowed physicians to prescribe alcoholic spirits if there was a medical justification. Not surprisingly, many "medical" reasons for drinking beer and liquor appeared after 1919. Similarly, the law allowed alcoholic beverages, particularly wine, to be used in religious ceremonies. Alcohol was also deemed legal in various industries when used in different chemical processes. Falsified documents led to many abuses of the law based on these provisions.

Despite the many abuses of Prohibition laws and flourishing crime, the public appeared to be largely oblivious to it. The stock market rode high through most of the Roaring Twenties, and nobody seemed to want it to end. Herbert Hoover easily won the presidency in 1928 while campaigning for Prohibition's continuance, referring to it as "a great social and economic experiment, noble in motive and far-reaching in purpose." Less than a year after his election, however, the stock market crashed and plunged the nation and the rest of the world into the Great Depression. Although it would take several years, this turn of events would ultimately spell an end to the "Noble Experiment."

HAPPY DAYS ARE HERE AGAIN!

Once Franklin Roosevelt was elected in November 1932 to serve as the nation's thirty-second president, it quickly became clear that Prohibition's days were numbered. Moral issues and politics now took a back seat to the economic realities of the Great Depression, which was now three years old with no end in sight, and Roosevelt recognized the potential economic benefits of resurrecting the brewing and distilling industries. Thousands of jobs would be created almost instantly, and the taxes generated on the new stream of revenue would provide a significant financial boost to the government.

Roosevelt took little time to act on the Prohibition issue; just one month after his inauguration, Congress proposed the Twenty-First Amendment to the Constitution (to this day, the only constitutional amendment that reverses a previous amendment) on February 20, 1933. When it was finally adopted on December 5, 1933, it legalized the sale of full-strength beer (up to 6 percent alcohol by volume). In the meantime, the Cullen-Harrison Act, enacted by the Congress on March 21, 1933, and signed by Roosevelt one day later, legalized sales of beer with an alcohol content of 3.2 percent, a level regarded as too low to be intoxicating; this act sped up the process significantly by taking effect on April 7, 1933 (this day is often referred to as "repeal," although full Prohibition did not officially end until eight months later). Upon signing the legislation, Roosevelt commented, "I think this would be a good time for a beer."

At midnight on April 7, a nationwide celebration took place as alcohol sales again became legal after more than thirteen years. The only problem was that beer and other spirits were not readily available to everyone, as the vast majority of breweries and distilleries had been dismantled. Only three breweries in Ohio had continued to produce near beer through 1933, and as their brewing equipment remained in place and functional, they were able to produce real beer immediately; in fact, all of the demand in the state was being supplied by these and several brewers in the Midwest. Also at issue was the fact that distributors, bars and restaurants did not yet have liquor licenses, so all of the available beer could only be sold directly from the breweries. As a result, all were swamped with customers, with available beer supplies being sold off within hours or days.

As soon as the Cullen-Harrison Act was signed in March, the Renner Products Company in Akron reverted to its original name: the George J. Renner Brewing Company. As one of Ohio's three breweries that had remained functional, it was the first in the state to receive a license to legally brew 3.2 percent beer. As beer orders began to arrive in the first few days of April, the company placed several advertisements in local newspapers, thanking the public for their loyalty and interest in the company's products. Another advertisement offered company stock to the public for the first time, in an effort to raise more capital for upgrading the plant's equipment.

When April 7 arrived, the company intended to wait until the next morning to begin selling beer, perhaps underestimating the public's voracious appetite after so many dry years. As it turned out, more than two thousand people showed up at midnight to get in line—or as the *Beacon Journal* described it the following day, "stormed the brewery." Fortunately for them, the company relented, as sales began at 12:01 a.m. First in line was Findlay resident J.C. Callahan, who had waited for two hours before getting his case of Grossvater Beer. While the mood was festive, the crowd remained orderly while beer was distributed as quickly as possible, with more than five hundred cases being sold that night.

Cases of twenty-four bottles sold for $3.25 (including a $1.00 deposit on the crate), a price that was noticeably higher than in the pre-Prohibition era, as new federal and state taxes came into play. Among those who took part in the festivities that night were Summit County sheriff Ray Potts, as well as the mayors of nearby Barberton and Massillon. In addition to those who showed up in person, there were thousands of orders from other cities, with truckloads of Grossvater traveling as far away as Pittsburgh. The company had five thousand cases of beer available for immediate sale that night, with

more in storage. By noon on April 8, more than ten thousand cases had been sold, with another two thousand cases on back order from accounts all over Ohio and Western Pennsylvania; several days went by before all the orders were filled. Beer had returned with a vengeance!

America was a very different place in 1933 than it had been in 1919, and the business of selling beer had changed significantly as well. Doing business during the Great Depression brought many new challenges, with overall decreases in lines of credit, operating capital and disposable income for consumers. Nationwide, many brewers saw wide swings between success and failure, with several notable brewers who had seen great success in 1933 filing for bankruptcy by 1935. A common cause for these problems was attempting to grow quickly to meet the high demand for beer, with many brewers taking on expansion projects that accomplished little except for increasing their debt to unmanageable levels. Renner resisted the temptation to expand, aside from modernizing its equipment over the next decade. When completed, this gave the plant an annual capacity of 100,000 barrels.

Instead, the company spent a great deal on improving its transportation and delivery system, with its brands now being distributed within a two-hundred-mile radius of Akron, reaching Western New York and Pennsylvania. The company purchased a large fleet of trucks, ranging from small vans for local deliveries to large tractor-trailer rigs for more distant

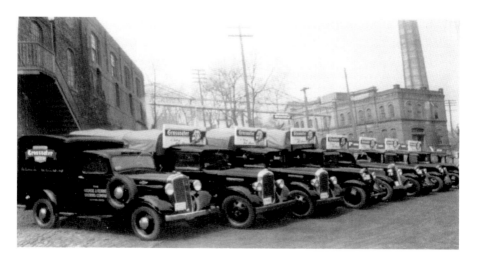

Renner's small fleet of delivery trucks was lined up in the brewery parking lot on this winter day in 1935. *Courtesy of Forge Industries.*

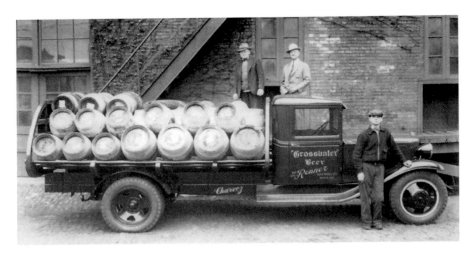

Another of Renner's delivery trucks is shown circa 1934, loaded with barrels. Standing on the loading dock are brewmaster Max Illenberger and company president Ernest C. Deibel. *Courtesy of Forge Industries.*

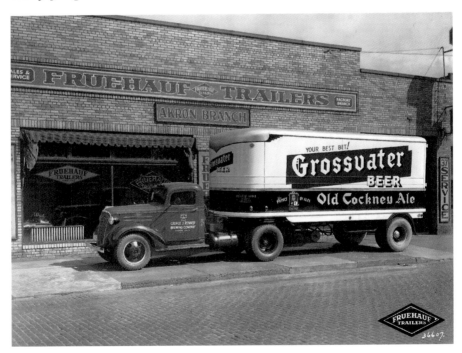

By the late 1930s, Renner was utilizing larger delivery trucks for long-distance sales, as its beers were being distributed in three states. This truck was made by the Fruehauf Company, circa 1940.

sales. In addition, the company hired Richard Barnes to be its first sales and advertising director, overseeing the company's marketing. This aspect of the brewing industry had also changed drastically from the pre-Prohibition era, as there were now far more opportunities to spread the word about one's brands. While newspaper advertising remained commonplace, point-of-sale marketing in grocery stores and bars became far more widespread, with beer brands being displayed prominently on signs, clocks, trays, bottle openers, foam scrapers, matchbooks and other items.

Another difference in marketing by this time was the appearance of a wider variety of brand names. While Grossvater Beer remained Renner's flagship brand throughout the 1930s, it was joined by Grossvater Ale in 1934. While the brewery had never previously produced an ale, the company was attempting to take advantage of a brief spike in interest in ale during the prewar years. This was renamed as Old Cockney Ale by late 1935 and was soon joined by Old Gross Half and Half, a mixture of beer and ale. Lucky Shoe Beer and Old German Beer, a low-budget brand with a plain black label, also appeared around the same time. Zepp Brew also remained in production for several years after repeal; being non-alcoholic, it could still be sold in areas where Sunday sales of beer were banned. In the late 1930s came the appearance of Souvenir Beer, a lighter-bodied brew that was in keeping with the public's changing tastes of the era. Of course, every spring saw the brief appearance of Grossvater and Souvenir Bock Beers as well. All of these new brands were devised by brewmaster Max Illenberger.

Another new innovation in the brewing industry after repeal was the packaging of beer in tin-plated steel cans. First introduced in East Coast test markets in early 1935, canned beer quickly became a popular alternative to bottles, although the use of flat-topped cans, requiring the attachment of a lid, required the installation of a separate canning line, which was an unaffordable option for many smaller brewers of the era. As an alternative, cap-sealed, cone-topped cans became available in 1936. While they were more difficult to stack in stores, they could be filled on existing bottling lines with only a minor adjustment and were a more cost-effective option. While cans had been used by brewers in Cincinnati and Cleveland from the beginning, it was not until 1938 that Grossvater became Akron's first canned beer, using cap-sealed cans made by Philadelphia's Crown, Cork & Seal Company. Known by collectors as "J-spout" cones, these cans were largely marketed in areas far from Akron, such as Western New York. By 1940, they had been succeeded by a unique package known as the Crowntainer. Also made by Crown, Cork & Seal, this was a squat can, also cap-sealed, which

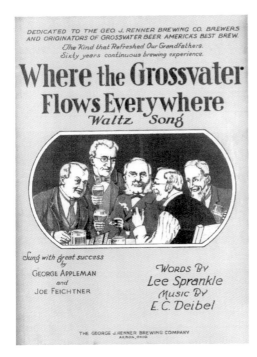

Left: Grossvater Beer had a waltz written in its honor shortly after Prohibition's end. With sheet music used in taverns and during promotional activities, the music was written by company president E.C. Deibel.

Below: Renner won an award for this display at the U.S. Brewery Expo trade show, circa 1940. Company president Ernest C. Deibel and brewmaster Max Illenberger share the trophy, surrounded by bottles, kegs, neon signs and piano sheet music written for Grossvater Beer. The NRA symbol refers to the National Recovery Act. *Bill Carlisle Collection*.

was also known as a "silver growler" or a "silver goblet." Just as canned beer was starting to catch on with the public, however, World War II brought a temporary end to can production between 1942 and 1947, with metal being in short supply due to the war effort.

The Renner family's other Ohio breweries also returned to business after repeal, although neither occurred immediately. In Youngstown, the family business had remained solid financially during Prohibition, thanks largely to its extensive real estate holdings. Once it became apparent that repeal would soon take place, the company's stockholders supported the spending of $250,000 to renovate the brewery, which was now more than forty years old and had been largely unused for more than a decade. The project employed two hundred local men and, when completed, brought the old plant's annual capacity up to 100,000 barrels (further expansion in later years would nearly double this number). By June, Renner's Beer and Ale were back on the market, along with a number of new brands. These were sold largely in the eastern Ohio market, with some sales into Western Pennsylvania and New York. Both owned and operated by members of the same extended family, the Renner plants in Youngstown and Akron chose to be "friendly competitors" and generally attempted to avoid selling their brands in overlapping areas.

The Renner & Weber plant in Mansfield, still operated by Weber and Renner family members, was also renovated, bringing its annual capacity up to fifty thousand barrels. However, its beers did not return to the market until March 1934. Its Lord Mansfield Ale and Red Band, Old German and Weber's Beers were largely marketed in Mansfield and territories to the west.

Although the Burkhardt Consolidated Company had closed its beverage division several years prior to repeal, its stockholders had every intention of returning to the brewing business when the time came. Instead of attempting to take advantage of the short-lived rush of sales in early 1933, President Gus Burkhardt chose to spend more time to renovate the entire plant. Armed with $500,000 of capital stock, the company replaced all its existing, outdated brewing equipment and other machinery, replacing it with the most modern equipment available. New glass-lined storage tanks were installed in the cellars, automatically keeping the beer at the correct temperature, while automatic conveyors helped to speed the movement of kegs, bottles and other items throughout the plant. New packaging equipment allowed the entire process of sterilizing, pasteurizing, filling and labeling of bottles to be done at one time. These operations took place

under the supervision of brewmaster George Dippel, a recent graduate of Chicago's Wahl-Henius Institute.

When the renovation was completed in November 1933, the brewery had an annual capacity of 150,000 barrels, employed more than one hundred men and was the nation's first completely air-conditioned brewery. The first post-Prohibition batch of Burkhardt Beer was made at that time and was ready for the market on January 8, 1934. Burkhardt Special and Select Beers, with slight variations in recipe, were soon joined by the company's seasonal bock beer (released every year in March and available for several weeks), XX Dark Special Beer, Old Scout Lager, Old German Lager Beers and Burkhardt's Ale. The latter was the first ale ever brewed by the company, but by the late 1930s, it had been reformulated and renamed as Mug Ale. A basic but popular brown ale, the new brand was marketed with the image of a bulldog named Mugsy and would remain in production for more than a decade after the other Burkhardt brands had been discontinued.

Burkhardt was the first Akron brewer to take advantage of the newest form of mass media advertising: radio. As early as 1936, the company was sponsoring programs such as *The Burkhardt Fishing Program* on WADC (Akron's oldest radio station, on the air since 1925); in 1943, it was sponsoring two serial dramas, *The Texas Rangers* and *The Hawk*, both on WAKR. Burkhardt also made great use of point-of-sale advertising, with many different types of signs and other advertising pieces surviving today in the hands of collectors. Newspaper advertising continued as well, with one particular series of ads in 1940 using two sisters known as "Beernice" and "Alene."

By this time, the company was distributing its beers into five states (Ohio, Michigan, West Virginia, Pennsylvania and New York), an area with a radius of 175 miles, using a fleet of twenty-eight-foot tractor-trailer rigs. Each of these could carry up to seven hundred cases of beer, weighing seventeen tons. In 1939, the company spent $25,000 to install a new pasteurization unit, followed by a new refrigeration system for the storage of frozen foods.

The late 1930s saw the arrival of the next generation of family management, with William G. Burkhardt assuming the position of vice-president. Born in 1914, he had graduated from Notre Dame University, followed by receiving a master brewer degree from New York's Wallerstein Laboratories. When the company celebrated its sixtieth anniversary in 1940, it was able to advertise the presence of three master brewers (William and Gus Burkhardt and George Dippel) on its staff. The company was riding high with a long-standing and well-respected name, good beer and good management. Burkhardt was Akron's top-selling beer in the prewar era,

Burkhardt completely renovated its plant with new, state-of-the-art equipment in the 1930s. Shown in a company brochure are hops being added to the brew kettle. *Bill Carlisle Collection*.

Left: Also in the same company brochure is this view of barley being delivered to the plant to begin the brewing process. *Bill Carlisle Collection*.

Below: Also in the same company brochure is this view of the modern, efficient bottling line, with filled bottles being capped. *Bill Carlisle Collection*.

despite the presence of several successful breweries in the Cleveland area, numerous breweries elsewhere in the state and in surrounding states and two others in Akron. While national brands such as Schlitz, Budweiser and Pabst had a presence in Akron, they were not yet dominant in the market. This would change by the end of the 1940s.

Although local drinkers cheered the return of the Renner and Burkhardt brands in the 1930s, The Akron Brewing Company was long gone, having been dissolved nearly a decade before repeal. This void in the local brewing industry would soon be filled by a new, albeit smaller, concern with a similar name.

Emmanuel Wiener had spent thirty years in the wholesale produce business and, by 1933, was operating his own E.H. Wiener Corporation out of a refitted factory building at 260 South Forge Street, along the city's main line of railroad tracks. The factory dated to the immediate post–Civil War period, when it was built as part of John F. Seiberling's Excelsior Mower & Reaper Works. Although it was one of the city's largest employers in the 1800s, the farm implement business had left Akron by 1905, leaving the building empty.

Wiener had occupied it by the 1920s, and although his produce business was successful, he was open to any new ways to make money during the Depression. The impending end of Prohibition led him to consider entering the brewing business, which he did just one week before repeal took place. However, raising the capital needed for brewing equipment took longer than expected, and a new charter was filed in early 1934 for his enterprise, known as Akron Brewing Company (no "The," to avoid confusion with its predecessor). Capital stock of $350,000 was raised from investors, allowing the new brewery to take shape over the next few months. Nearly seventy years old, the three-story brick factory building was still ideal for construction of a brewery and was easily able to support the heavy vats and other equipment. Once complete, the plant had the capability to produce as much as seventy-five thousand barrels per year.

On April 30, 1934, the new brewery officially opened for business, as the first batch of White Crown Beer was released to the public in bottles and on tap. Advertised heavily in area newspapers, the new brand had a logo featuring a jolly king wearing a crown. Several months later, White Crown Ale made its appearance; another brand, Old German Lager Beer, would appear in 1936, and White Crown Bock Beer was made for a short time every year in the spring. All of these quickly established themselves as viable brands in the increasingly congested beer market of Northeast

Ohio. Throughout the company's existence, its operations were overseen by brewmaster Charles A. Kraatz, a member of a family of brewers who had worked in multiple cities across the state in the pre-Prohibition era.

Despite the young company's early successes, it soon encountered financial setbacks, including issues with organized labor. By 1935, the company had defaulted on a loan that was used to build a produce warehouse next door in 1928. As a result, the Wiener Corporation was dissolved, and ownership of the brewery was transferred to the Carmichael Construction Company, which had built the warehouse. Cornelius and John J. Mulcahy, owners of Carmichael, then became chairman and president, respectively, of the brewery.

White Crown sales remained profitable through the remainder of the decade. By 1940, the brand was outselling Renner's Grossvater Beer, as the company had become the city's second-largest brewery by volume. In that same year, F. Charles Bristol took on the position of general manager, assisted by sales manager Tom LaRose and his brothers, Joe and Peter. The onset of World War II would bring an end to the company's successful run, however, as wartime rationing of grain, metal, gasoline and other materials severely limited the company's output. In 1943, it accepted an offer by Cleveland's Leisy Brewing Company to purchase the Akron company's grain rations (an amount established by the government based on prewar output) and other assets. This brought production in the Akron brewery to a halt, as the company existed in name only after that point. The equipment was liquidated over the next few years, and the building was vacated by 1947.

The LaRose brothers remained in the brewing business, operating the Akron Distributing Company, which had begun as an outgrowth of a family bus company. This would later become the House of LaRose, which remains in business today as one of the nation's largest distributors of Anheuser-Busch products. The complex of buildings in which the brewery operated was used by several companies for warehouse space until being purchased by the nearby University of Akron in 1979. The oldest section, more than a century old, was razed shortly after this, although the newer warehouse next door was converted into the Sidney L. Olson Research Center, housing the university's biomedical engineering department to this day.

Statewide, sixty breweries opened for business in the early post-Prohibition era. Of these, eighteen had already closed by the onset of World War II, a sign of things to come. The war and its aftermath would

bring dramatic changes to the American brewing industry, leading to some of its most rapid growth ever. However, shifting trends in customer preferences and loyalties would spell the end for many old brand names along the way, as modern marketing allowed a few industry giants to dominate the landscape. Akron's brewers would experience this trend as strongly as any location in the country.

THE POSTWAR YEARS

President Roosevelt was accurate in his declaration that December 7, 1941, was "a date which will live in infamy," as the United States declared war on Japan the following day, while entering the European war as well. These actions would dramatically affect the course of history worldwide and, on a smaller scale, would have significant effects on the brewing industry as well, both short- and long-term.

Immediately after the United States entered the war, young men began joining the military by the thousands. Ultimately, 16 million Americans served in the military during the war, a significant portion of the population, which was roughly 135 million at the time. While this led to a decrease in the available labor force, brewers were able to find substitute workers to remain in operation. Military service was not limited to the industry's laborers; nationwide, many brewery officers were forced to leave their companies behind as they fulfilled their military service. William Burkhardt was one of those, seeing active duty in the Pacific Theater as an ensign in the United States Navy Reserve. Similarly, Robert Holland, the future president of the Renner Brewery, spent time serving in the air force during the war.

Many brewers, including Burkhardt, incorporated pleas to buy war bonds into their wartime advertising, displaying their patriotism while marketing their product. Some brewers with German backgrounds felt more of a need to do this, as anti-German sentiment began to rear its ugly head just as it had done during World War I. While not as strong as it had been previously, the sentiment still led many brewers to eliminate brand

names that had Germanic backgrounds. Each of Akron's three brewers at the war's outset made a brand known as "Old German," and this name was temporarily eliminated. Renner's Grossvater Beer, on the market for thirty years by this time, was temporarily put on hold in favor of the Souvenir brand during the war, although Grossvater returned several years after the war's end.

Of greater concern to the brewers, however, was the rationing of metal, gasoline and grain, items that affected their day-to-day operations. Delivery schedules were greatly affected by gasoline limitations; in Akron, the Summit County Brewers Association imposed a policy reducing overall beer deliveries, while banning home deliveries altogether. Grain was rationed by the government, based on the prewar amount of grain used. As the city's largest brewer by volume, Burkhardt received a generous ration, while Renner and Akron Brewing received smaller ones.

Limitations on the use of metal had varying effects, such as ceasing the usage of metal cans during the war, but in Akron, this only affected the Renner Brewery, the only one to use cans by that time. However, all brewers sold beer in bottles, and bottle caps were a necessary feature of these. Limitations on the number of caps that could be used led many brewers to market larger quart-sized bottles during the war, selling more beer but using fewer caps. Another effect of the war was that virtually all brewery expansion projects were put on hold, due to a combination of reduced manpower and decreases in available equipment, parts and more. Regardless of all these wartime challenges, the demand for beer remained strong as ever, and many brewers saw tremendous success during the era. Ironically, far greater challenges would come after the war's end, for a variety of reasons.

On Forge Street, the George J. Renner Brewing Company remained in operation at the war's end, but its leadership was aging fast. Max Illenberger, who had been the company's brewmaster since 1917, retired in 1948. His successor, Anthony Weiner, had been the assistant brewmaster for many years but still brought a more modern approach to the position. Ernest Deibel, the company's president for many years, remained in that position until his death in 1950 at the age of eighty-seven. He was briefly succeeded by a cousin, also named Ernest Deibel, who died just one year later. His successor was Robert F. Holland, a Renner family descendant from Barberton. Holland had joined the company as a cashier in 1936 and had quickly worked his way up to being the treasurer by 1940. Although his youthful approach to the brewing industry might have served the company well, it was far too late by that time to alter the company's fate.

Souvenir had become the company's flagship brand during the war, and it sold well, especially after canned beer returned in mid-1947. Grossvater Beer, which had become an afterthought during the war, returned in the spring of 1948 with Brewmaster Weiner's new recipe and a new, modern label. Around the same time, the Crowntainer cans, which had recently returned to production, were abandoned in favor of taller, standard cap-sealed cans. The changes did not alter the company's sagging sales, and a group of industry "experts" was called in to analyze the company's production and marketing methods. Even after the company followed its recommendations, sales still did not improve, as the company was ill-suited to compete with the larger growth-minded regional and national breweries that had begun expanding quickly after the war's end. Because of that trend, smaller, older companies like Renner were increasingly being left behind.

As losses began to steadily mount in the early 1950s, the company's directors decided to end brewing operations altogether; the message was sent out to the company's 105 stockholders, who held a total of twenty-seven thousand shares of stock. The final brew was made on December 8, 1952, and after this beer was packaged and sent out for sale six weeks later, the company ended production after 104 years at the site. Although all brewing equipment was subsequently liquidated, the Renner Akron Realty Company continued to operate out of the same offices, still run by Robert Holland. The old plant, with the original building from 1873 at its center, has since served as home to a number of small businesses. It remains almost entirely intact today on the Forge Street hill.

In Mansfield, the Renner & Weber Brewery had scaled back its brewing operations after the war's end and had operated more as a distribution point for beers brewed in the Akron plant. In 1951, all brewing operations ceased, and the small plant at 75–85 East Fourth Street was liquidated. The buildings remained empty for years until being entered into the National Register of Historic Places, as a large-scale renovation was planned for the complex. This never took place, however, as the entire plant was destroyed in a spectacular fire in 1978. One small building from the complex is all that remains at the site today.

The Renner Brewery in Youngstown fared reasonably well in the postwar era, mainly because it had little local competition in eastern Ohio. Because it did not undertake a large plant expansion, it did not incur a large debt load and was able to remain financially solvent for much longer than many Ohio brewers. Beginning in 1948, the company was operated by Bob Renner and C. Gilbert James, both descendants of George J. Renner. Olde Oxford Ale

The Renner brewery on Forge Street as it appeared in 1994. Today, the nearly 150-year-old plant has changed little and continues to be occupied by several small businesses.

and Old German Beer, which had been in production since the mid-1930s, were joined in 1952 by Golden Amber Beer, a new, light-bodied beer in the style that modern consumers were seeking. With a young Bavarian man known as Sneaky Pete as its logo, it quickly became the city's best-selling beer, remaining in that position until the end of the decade. King's Brew, a low-budget brand, also made its appearance several years later.

By the end of the decade, however, competition with national brands had taken its toll on sales. A million-dollar investment in the company's equipment was made in 1960, followed by the installation of a new canning line, using flat-topped cans for the first time (Renner was one of very few brewers nationwide that was still using cone-topped cans up to this point). Despite these and other moves, the company was posting losses of nearly $50,000 per year, leading to the cessation of brewing activity in November 1962 and the liquidation of the plant as nearly a century of brewing by the Renner family came to an end. The old brewery on Pike Street remained vacant until it was destroyed by fire in 1978. The remaining brand names were sold to the Old Crown Brewing Company in Indiana, with distribution continuing in eastern Ohio until that brewery closed in 1973.

In order to maintain a stream of income for stockholders as brewing operations were winding down, the Renner Company had purchased the local Miller Spreader Company, a manufacturer of paving equipment. In 1968, Renner merged its assets with the Renner Akron Realty Company, forming a holding company known as Forge Industries. This company would later relocate to Boardman, a Youngstown suburb, where it continues to operate today. Still managed by family members, including Chairman Carl James, a local attorney and great-great-great-grandson of George J. Renner, the company also owns Bearing Distributors Incorporated, a prominent international supplier of steel bearings. Although the brewing business that George J. Renner purchased in 1888 has a very different appearance and operates in a different city today, it is still alive and well.

Meanwhile, on Grant Street, the Burkhardt Brewing Company would experience some of its most successful years during the early postwar era. President Gus Burkhardt had died of a heart attack in 1944, leaving thirty-year-old William Burkhardt to guide the company through the next decade (although he was on active duty with the U.S. Navy Reserve at the time). One of his most important accomplishments was to maintain and expand an active marketing plan, effectively making *Burkhardt's* a household word in 1940s and '50s Akron. The timing was particularly important, as the city's population grew by 12 percent in the postwar years, due largely to a rejuvenated automobile industry and the need for tires; the population would eventually peak in 1960 at 290,000.

After the company hired Cincinnati's Rollman & Peck ad agency to oversee its marketing plan, point-of-sale advertising for Burkhardt became even more commonplace in Akron and surrounding cities. Neon and fluorescent signs, clocks, trays, matchbooks and many other advertising pieces appeared in bars and grocery stores. Booklets were given away with recipes that went well with Burkhardt Beer, and others were given away with hunting tips, sports information and so on. One novelty item, unthinkable today, was a pack of cigarettes with the company logo on them, to be given away to patrons as a courtesy. The company also continued its sponsorship of a local semipro football team, the Burkhardt Brewers. While they did not achieve the success of the Akron Burkhardts in the pre-Prohibition era, the sponsorship was just another way to get the word out about Burkhardt's beer.

Also playing an increasing role in the company's marketing strategy was television, a relatively new form of mass marketing. In 1954, *Burkhardt's Custom Inn* appeared on Cleveland station WNBK, Channel 4 (today WKYC,

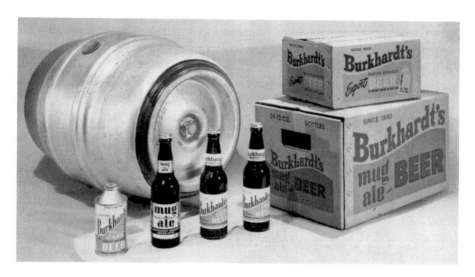

Burkhardt Beer and Mug Ale came in multiple types of packaging by 1950, as seen in a company brochure. *Bill Carlisle Collection.*

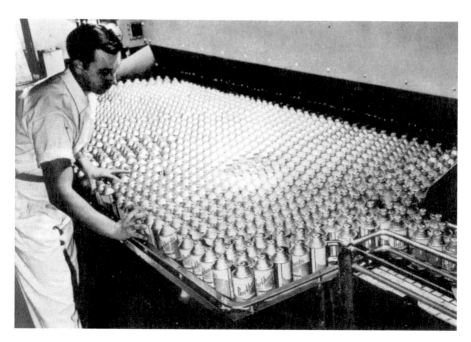

Burkhardt began canning its beer in 1948, using cap-sealed cans on a modified bottling line. As seen in a company brochure, empty cans were being manually fed onto the line to be filled. *Bill Carlisle Collection.*

Channel 3). Running nightly at 11:15 p.m., the fifteen-minute program was set in a fictional tavern in which local entertainers would appear and talk or sing. On the same station was *Burkhardt's Home Theater*, which ran a feature film every Wednesday night. On WXEL, Channel 9 (today WJW, Channel 8), the brewery sponsored sports programming from Madison Square Garden every Friday night in 1953.

While canned beer had not played a large role in the brewing industry in the prewar era, it became increasingly popular with the public when canning resumed after government restrictions on metal usage ended in 1947. Looking to give customers another option for home sales, Burkhardt began canning its beer in 1949, using the cap-sealed, cone-topped variety made by the Continental Can Company. Both Burkhardt's Special and Export Beers appeared in cans over the next two years, along with Mug Ale. In 1952, when the brand's label was completely redesigned with a stylish trapezoid logo, it was noted as "Master Blended" Beer.

Although the cone-topped cans were more economical, being filled on one of the plant's two bottling lines, they were more difficult to carry, requiring specialized cardboard six-pack and twelve-pack carriers. They were also more difficult to stack in store displays. In 1953, Burkhardt made the investment in a new canning line for flat-topped cans; the investment was felt to be worthwhile, as it allowed the brand to compete more successfully for limited display space in beverage and grocery stores. Burkhardt's beer, now noted to be "Custom Brewed," and Mug Ale, which also sported a completely redesigned label, both appeared in the flat-topped cans for the next three years.

The company found another stream of revenue in the early 1950s by packaging brands of beer and ale for supermarkets. While this trend was common on the West Coast as early as the mid-1930s, it wasn't commonly seen in the Midwest until the postwar era. The Tudor brand of beer and ale was the most prominent of these, made for the nationwide A&P grocery store chain. The brand was made by a number of brewers across the country over a span of more than twenty years, but between 1954 and 1956, it was produced by Burkhardt in both cans and bottles. Similarly, Banner Beer and Ale, Best Beer and Ale and Embassy Club Beer and Ale were also produced by Burkhardt for various grocers.

Recognizing by this time that the prevailing trends in the brewing business did not favor midsized brewers such as Burkhardt, the family had continued to expand its business interests into more diverse fields. The Burkhardt Consolidated Company continued to run the business end of the brewery,

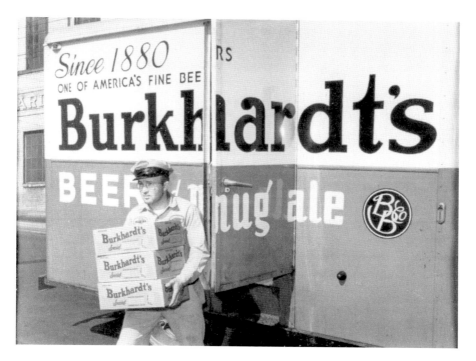

Burkhardt delivery truck parked on Grant Street in 1950, being loaded with cartons of canned beer.

as well as its associated activities such as the City Ice & Coal Company. The real estate division had shifted by this time from management of former saloons to land development and leasing of existing properties. The company also purchased a small existing insurance firm in 1952, renaming it as the Burkhardt Insurance Company. A new generation of family management was completed in 1953, when Gus Burkhardt Jr., William's cousin, assumed the position of company vice-president. Only twenty-four years of age, Gus was a recent graduate of Northwestern University, and although he was not trained in brewing, he was well versed in business matters.

While Burkhardt had undergone a modest postwar expansion, bringing its annual capacity up to 300,000 barrels, its larger regional competitors in Cleveland, Pittsburgh and Detroit had undergone far larger expansion projects and were marketing their brands even more heavily. Of greater concern were the national brewers such as Anheuser-Busch, Schlitz and Pabst, which were able to sell their brands from coast to coast and had the advertising budgets to make themselves household names nationwide.

Burkhardt again redesigned its label in 1955 for its Diamond Jubilee, a six-month celebration of the company's seventy-fifth year in business. Ironically, its assets were sold to Cincinnati's Burger Brewing Company shortly thereafter.

Despite Burkhardt's heavy marketing push of the postwar era, the company's profits had stagnated and had begun to decrease by the mid-1950s. It was feared that brewing might soon become unprofitable altogether.

These concerns were hidden from the public in 1955 as the company celebrated its seventy-fifth anniversary. The six-month "Diamond Jubilee" was commemorated with a new recipe, known as Burkhardt's Premium Light Beer, along with specially redesigned cans and bottle labels. The public was invited to visit the brewery for tours during the celebration, which would truly be the company's "last hurrah." Sadly, although the new lighter-bodied beer proved to be a hit with the public—as it was exactly what consumers were seeking in the mid-1950s—its arrival was far too late. Had it been released several years earlier, it may well have helped prolong the company's existence.

In early 1956, the search began to find a buyer for the plant, and in June, a deal was finalized with Cincinnati's Burger Brewing Company in which the latter would purchase all of Burkhardt's brewing equipment, stock and buildings for just over $2 million. And just like that, the Burkhardt brand of beer was snuffed out like a candle. The plant immediately converted production to the Burger brand of ale, beer and seasonal bock beer, although it kept the Mug Ale brand in production as well. The latter was a nut brown ale, as opposed to the pale ale that carried the Burger name.

Despite the loss of its brewing division, the family business remained in operation with its related functions. However, just one year after the sale, Gus Burkhardt Jr. was killed in a tragic automobile accident at the age of twenty-eight. This left William Burkhardt as the primary family member in the business until his sons, William Jr. and Thomas, came of age.

The City Ice & Coal Company closed in 1960, also a victim of changing times. The realty and insurance divisions, however, continued to flourish

for many years. After William Burkhardt died in 1972, his sons maintained operations themselves. The insurance division was eventually sold off as real estate development became the primary business. The family owned a large tract of land west of the city where it had maintained a horse farm for its delivery wagons in the old days. Having put the first water and sewer lines into the area, it was instrumental in developing the large commercial district known as Montrose. The land where the family farm was located is now occupied by a Lowe's home improvement store.

The brothers split the company's assets in the early 1990s, as Thomas pursued a return to the brewing business (covered in the next chapter), while William Jr. maintained the real estate business as Burkhardt Consolidated. When he retired in 2008, the business was sold to Shelley Taray, who renamed it Taraco Associates Inc., still maintaining and developing commercial properties over a several-county area. William Burkhardt Jr. died in 2010.

Like Burkhardt, the Burger Brewing Company had a lengthy history and was attempting to expand its output in order to remain a factor in the regional brewing industry. Founded in 1880 by German immigrants Louis and Charles Burger, the Burger Brothers Malting Company focused on malt production during the pre-Prohibition era. After surviving Prohibition, the company entered the brewing industry in 1934. The company occupied a huge brewery along the city's Central Parkway that had previously been operated by the Windisch-Muhlhauser Brewing Company since its construction in 1866. By the mid-1950s, it was one of the largest brewing concerns in Ohio, with an annual capacity of 1.2 million barrels and roughly 475 employees; its Burger Beer and Ale were sold throughout a large portion of the Midwest, South and Mid-Atlantic regions. With the company having a goal of becoming a major regional brewer, the addition of an Akron plant was the first step of an expansion process in which it hoped to expand its sales throughout northern Ohio and into territories farther east. Specifically, it would be in a position to go head to head with Cleveland's huge Carling Brewing Company.

Overseen from Cincinnati by Burger president W.J. Huster and vice-president J.F. Koons, the Akron plant and its 185 employees were managed locally by Frank Sellinger. George Dippel, Burkhardt's brewmaster since repeal, remained with the company under the supervision of Cincinnati brewmaster Carl Neubauer. Joseph Ciriello, Burger's northern Ohio sales manager, now oversaw all sales from the Akron plant.

Both Burger Beer and Mug Ale were packaged in bottles and cans; in about 1960, the company experimented with a new all-aluminum can.

Despite being lighter to carry and easier to open, the can suffered from production problems on the canning lines and was never released to the public. However, around the same time, the company began using aluminum tops on its cans. Much easier to open with a "church key" can opener than traditional steel tops, these had become commonplace in the industry by this time. Although the self-opening zip tab was invented in 1962 and was used in Burger's Cincinnati plant, it was never used in the Akron plant.

Although the largest regional and national brewers continued to battle for industry supremacy through the 1950s and early 1960s, Burger held its own in its targeted markets. A.J. Hausch was promoted in 1960 to manage the Akron plant, which continued to run efficiently and safely. Since repeal, the plant had been one of the safest in the nation in terms of worker accidents. In 1955, Burkhardt's last full year of operation, it was one of only twelve breweries nationwide to have zero worker accidents.

In 1964, however, Burger made a relatively abrupt decision to close the Akron facility. While the plant was still operating efficiently, Burger had not been successful in expanding into the targeted northeastern United States markets after eight years, and the decision was made to focus on strengthening its market shares in existing areas of the South and Midwest. Publicly, however, the company's stated reason for closing was that Ohio's tax structure made it far more difficult for brewers to make a profit on any beer brewed in the state, preventing the Akron plant from operating in a cost-effective manner.

This same issue had already played a major role in the closure of multiple large breweries across the state during the era. Ohio state tax on a standard case of beer was thirty-six cents; only Michigan charged its brewers more, while Wisconsin and Missouri, home of the nation's largest and most dominant brewers, charged only seven cents per case. Burger continued to operate in Cincinnati but began to encounter more financial problems as the decade wore on. In 1973, it closed its plant altogether, selling its brands and assets to the local Hudepohl Brewing Company. More than forty years and several corporate sales later, Burger Beer remains in production today, produced by a division of Cincinnati's Christian Moerlein Brewing Company.

Back on Grant Street, the old brewery closed its doors for the first time in nearly a century, as Akron's brewing industry ground to a halt for the first time in 119 years. After the plant was vacated, the large bottling plant was sold to the Akron Public School system, which still owns it today. The large stable and garage building on the south side of the complex was sold to the

The former Burkhardt bottling plant, built in 1916. It has been used for many years by the Akron Public School System for storage.

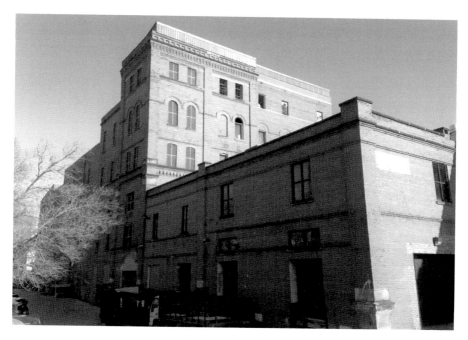

The former Burkhardt brew house as it appears today; the Aqueduct nanobrewery operates in the rear of this building. Although the brew house has been vacant for more than fifty years, it remains structurally sound.

Best Moving & Storage Company in the 1940s; it later housed a beverage distributor. A faint painted advertisement for Burger Beer in aluminum-topped cans can still be seen on its side wall, while two concrete horse heads remain over its front doors today as a reminder of the building's original purpose. A portion of the office building was used for a time by Burkhardt Consolidated and later was occupied by the Buckeye Metal Fabricating Company. A large portion of it is occupied today by the offices of the Thirsty Dog Brewing Company, covered in the following chapter.

The craft brewer has renovated a large portion of the plant, including the former power plant and portions of the brew house, which had been empty and derelict for many years. A separate craft brewer, the Aqueduct Brewing Company, operates in the rear portion of the plant, which has access to some of the original stone-lined beer cellars, built in the 1870s. The upper floors, unused for more than half a century, continue to decay as of this writing, making their exploration difficult and potentially dangerous. The former brew house floor has huge holes in it where the brew kettle and other equipment were removed long ago. However, proposals have been made for further renovations of portions of the plant, so its future appears much brighter than it did just a decade earlier.

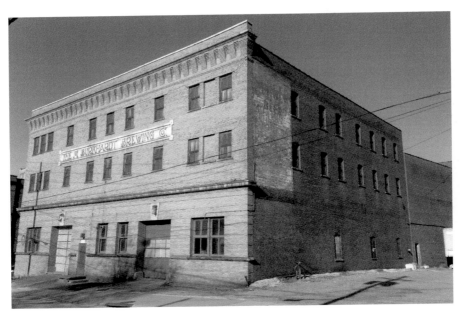

The former Burkhardt stable and garage building on the south side of the plant. A faint advertisement for Burger Beer in cans can still be seen on the wall.

Two concrete horse heads remain in place above the main door to the stable building, along with the company name in stone letters.

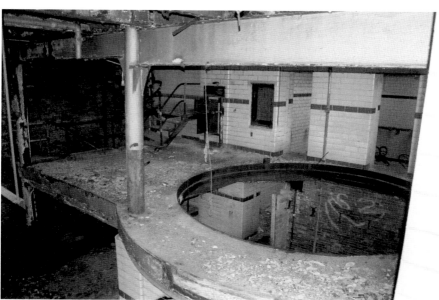

The interior of the former brew house has a huge space in the floor where the brew kettle once stood. A large amount of debris and graffiti is present throughout the building.

Intense national competition had taken its toll; the postwar demise of Ohio's brewing industry mirrored that of the nation as a whole. Statewide, twenty-four breweries had closed between 1948 and 1954. As this disturbing trend continued over the following decade, larger and larger brewers began closing their doors as well; most of these had been highly profitable as late as 1953. By the time Burger closed its Akron plant, only eight breweries remained in Ohio, and that number would drop to a mere four by the end of 1974. The future of brewing in Ohio looked bleak, to say the least.

THE INDUSTRY IS REBORN

After Burger closed its Grant Street plant in 1964, it seemed to many that professional brewing would never return to the Rubber City. In fact, it seemed that brewing in Ohio in general was an endangered species. By that time, Cleveland was left with only two operating breweries: the Carling Brewing Company operated a huge plant on the east side of town and distributed nationally, while C. Schmidt & Sons, with headquarters in Philadelphia, operated on the west side. By 1971, Carling had left town, leaving only Schmidt, which subsequently moved its operations to the former Carling plant; this finally closed in 1984.

Elsewhere, Toledo's historic Buckeye Brewing Company, with more than 125 years of beer production, closed in 1972. After Burger's main plant in Cincinnati closed in 1973, only the Hudepohl and Schoenling breweries remained in operation there. In Columbus, the August Wagner Brewing Company, open since 1906, remained in business until its closing in 1974. Its demise was hastened dramatically by the opening in 1968 of a new plant, just a few miles away, by worldwide giant Anheuser-Busch. Known today by many Ohioans due to its prominent location along Interstates 71 and 270 and its tall towers spelling out "Budweiser" and "Bud Light," the plant was already the state's largest brewery at the time of its opening. Multiple enlargements since then, however, have left it as one of the company's largest plants, with an annual capacity in excess of 10 million barrels.

Competition like that can make life miserable for any smaller brewer, and life was made even worse in 1991 with the opening of another similar-

sized plant, owned by Milwaukee's Miller Brewing Company, just north of Cincinnati in the town of Trenton. By that time, the only original Ohio brewer to remain was Schoenling in Cincinnati, a name that would disappear in 1997 when its plant was taken over by the Boston Brewing Company, maker of Sam Adams Beer. It had become obvious that in the brewing industry, like so many other industries, the big just get bigger. Therefore, by the late 1980s, it seemed to most Ohio beer drinkers that they had no choice but to drink uniform, mass-produced beers with a very limited number of styles and flavors, as the art of brewing continued to fade away in favor of corporate "beer factories."

It was in that environment, in the most unlikely of circumstances and against all odds, that the Akron brewing industry was, in fact, reborn, thanks to the son of the last successful Akron brewer. Tom Burkhardt, son of William Burkhardt, had worked for the family's real estate company for many years but had also dabbled in home brewing as a hobby since it was legalized in 1978. In late 1990, he took his hobby to the next level by becoming a professional brewer like his ancestors before him. He represented the fourth generation of the family to be involved in the brewing industry when he purchased the former Tavern on the Green restaurant at 3700 Massillon Road in the city of Green, ten miles south of Akron. After installing a seven-barrel system (consisting of English-made Grundy tanks) across the hall from the restaurant, brewing operations began in April 1991. After a twenty-seven-year hiatus, the brewing of beer had returned to Summit County!

While craft brewing was new to the area, the concept was more than a decade old on a national level. Opening in 1977, the New Albion Brewery in Sonoma, California (just north of San Francisco), had been the nation's first brewpub. Although it closed after just five years of business, it sparked an interest in others who saw the potential to brew unique beers in small batches, enjoying brewing as an art instead of purely as a source of revenue, to be produced by the cheapest and most efficient methods possible. Although the concept spread slowly, it reached Ohio in 1988, when the Great Lakes Brewing Company opened in a small way in the Ohio City district of Cleveland. Now thirty years old and counting, Great Lakes has been successful on every level, winning countless awards and inspiring nearly every other craft brewer in the state (and other states), as it has gradually grown from a small brewpub to a large production facility, with distribution over a wide area of the nation.

Great Lakes was certainly an inspiration to Tom Burkhardt, who had tried many different recipes while brewing at home over the years, despite

a lack of formal training. While taking time off from the real estate business in 1988, he became aware of what Great Lakes was doing in Cleveland and that it was being well received by the public. Quite aware of his family's legacy in the field, he wanted to bring the Burkhardt name back to prominence and felt strongly that the beers should be brewed by the family, not contract-brewed by a larger company elsewhere (as was frequently being done in similar situations around the country at the time). Working with his wife, Linda, and son, Tom Burkhardt Jr., he put the new brewery together over a roughly eighteen-month period, working in largely uncharted waters since brewpubs were so few and far between at the time.

The opening of his new venture was well publicized due to its local historical connection, and a solid clientele was quickly established. The brewery's water source was a series of wells, producing a fairly hard type of water with a high mineral content. This was similar to the quality of the water found in Burton-Upon-Trent, England, which is known worldwide for its ale breweries, such as Bass. As a result, Burkhardt chose to focus on ale production in the early days, and upon opening, he offered Northstar Golden Ale, White Cliff Amber Ale and Eclipse Dark Ale. A wide variety of seasonal styles (such as honey ale, raspberry ale, Irish red, bock beer and Oktoberfest Beer) was made as well, in limited batches. In 1994, Burkhardt found the company's original recipe for Mug Ale, which had been dormant since the early 1970s. He soon began producing the old favorite again, using the brand's original logo and marketing that had last been seen in the mid-1950s. With a trendy "retro" appeal, the brand found a ready market. All of Burkhardt's brews were sold exclusively in the restaurant or in take-home growlers.

After Tom Burkhardt Jr. left in 1995, he was succeeded by Chuck Dahlgren as the main brewer. An expansion of the brew house a year later allowed him to make two brews per week, raising the annual capacity to seven hundred barrels. Three years later, looking to expand the operation, Burkhardt opened a second location at 3571 Medina Road, on the east side of the city of Medina, fifteen miles west of Akron. With more emphasis on the historic aspects of the company, the new location used a three-and-a-half-barrel brewing system, still overseen by Dahlgren. Wolf Creek Pale Ale, named for the water source originally used by the family's Grant Street brewery, and Burkhardt's Select Export Lager were added to the lineup of Eclipse and Mug Ales and a rotating list of seasonal brews.

In 2000, the original restaurant in Green was closed, with all brewing activity consolidated at the restaurant in Medina. In late 2001, Burkhardt

Tom Burkhardt brought the family name back with his brewpub in suburban Green in 1990. The son of William G. Burkhardt, Tom later added a small brewery in Medina and remained in business for eleven years.

closed the Medina facility as well, for personal reasons. In his eleven years of brewing, however, he had not only introduced Summit County to the era of craft beer, but he had also extended the family's brewing legacy into the modern age.

The area's second craft brewery, and the only one of the 1990s to open within the Akron city limits, was the Liberty Brewing Company. Located at 1238 Weathervane Lane in the Liberty Commons office park in the Cuyahoga Valley, Liberty opened in late 1994 and marketed itself as the city's first brewery in thirty years, which technically was true. The venture was owned by David Russo, Chuck Graybill and Rory O'Neil, who came from a variety of backgrounds, although none had experience in brewing. For that, they enlisted Tim Rastetter from the Great Lakes Brewing company to establish their brew house and beer recipes. However, since Russo had an extensive background as a chef and had spent a great deal of time training in New Orleans, Liberty's focus was as much on the menu, which had a definite Cajun flair, as it was on the beer.

Rastetter was no stranger to success, having accumulated several gold medals in national competitions while at Great Lakes. He soon assembled

Liberty Brewing Company

Akron's First Micro-Brewery/Restaurant

Invites You To Join Us For Our

GRAND OPENING CELEBRATION

of

MARDI GRAS

Tuesday, February 28, 1995

Featuring:

6 DIFFERENT CRAFT-BREWED BEERS ON DRAFT RANGING FROM MILD ALE TO STOUT. TRY OUR BEST-SELLING DRAGONSLAYER™, SCOTTISH EXPORT ALE!

IN ADDITION TO OUR REGULAR CONTEMPORARY AMERICAN CUISINE WE WILL FEATURE A VARIETY OF CAJUN AND CREOLE SPECIALS

INCLUDING:

CRAWFISH BOIL

2 LBS. OF LIVE LOUISIANA CRAWFISH IN A TRADITIONAL CREOLE BOIL. RED POTATOES, ANDOUILLE SAUSAGE AND CORN-ON-THE-COB

ONLY $18.50

Due to shipping from New Orleans and preparation time, we ask that you reserve your Crawfish Boil by Monday, Feb. 27th at 5pm

OPEN FOR LUNCH 11:30AM-2:00PM DINNER 5:30PM-10:00PM

1238 WEATHERVANE LANE 869-2337

The Liberty Brewing Company (later renamed as the Liberty Street Brewing Company) was the first brewery to operate in the city of Akron in more than thirty years when it opened in early 1995.

Liberty's seven-barrel brew house, which produced two brews per week and yielded roughly one thousand barrels per year, and established the company's standard lineup of ales, porter and stout. These were headlined by the most popular brand, Dragonslayer Scottish Export Ale, and were followed by a long list of seasonal and specialty brews, many having names that related to the area (such as Cascade Locks Ale). Just in the first year of operation, several of these brands won gold and silver awards at the Great American Beer Festival and elsewhere. More awards would follow in the coming years.

In 1995, the rights to the "Liberty" name were challenged by Fritz Maytag, the owner and operator of San Francisco's legendary Anchor Steam Brewery (although established in 1896, it was one of the nation's pioneers of craft brewing). One of the Anchor Brewery's primary brands is Liberty Ale, and Maytag boldly claimed ownership of all usage of the word. Instead of pursuing complicated legal action, the Akron brewpub had voluntarily changed its name to "Liberty Street" by 1996. In that same year, Rastetter left to establish another craft brewery at the Brew Works in Covington, Kentucky. A succession of brewers followed over the next five years, all while maintaining the same basic lineup of brews.

Although the pub stayed busy most nights, its clientele was largely young and professional. As a result, it was hit hard by the stock market decline of the early 2000s. "This economic downturn is definitely affecting us," stated Rory O'Neil in June 2001. "We've been struggling for a while and I don't see a bright light ahead." Just days later, on June 16, the pub closed, idling its forty staff members. When no buyers came forward, the brew house was dismantled, and brewing in the city of Akron came to a temporary end yet again.

Located twenty miles north of Akron, Northfield Park is a harness racing track that was built in 1957 on the site of a former midget car racetrack. Located at 10705 Northfield Road, directly on the line separating Summit

Located in an office park in Merriman Valley, north of downtown Akron, Liberty Street was popular with a largely young urban professional crowd; it closed in 2001, a victim of a bad economy.

and Cuyahoga Counties, it became the nation's first racing site to feature an in-house craft brewery in June 1998. Part of a $10 million renovation of the entire track, the facility consisted of a twenty-barrel system, with brewing overseen by David Gunn.

A fairly standard array of brews was produced at Northfield: red ale, cream ale, stout and a lager, in addition to a number of seasonal variations. These were available at the bars and concession stands throughout the track, as well as a small amount that was bottled for sale in the clubhouse dining room. By the end of 2005, however, the novelty had worn off, as the brewery ceased operations and the equipment was sold off. The concept did not die there, however, as Scioto Downs in Columbus, a similar harness racing track, sports its own craft brewery today.

Until the summer of 1998, all of the Akron area's craft brewing enterprises had been brewpubs, having food service combined with the brewing operation. That changed with the opening of the Blimp City Brewery in a small industrial park on Tallmadge Road in Brimfield, just east of the Portage County line. Operating as a pure microbrewery, it was established by Tim, Nancy and Mark Kuss with a ten-barrel brewing system, which had the capacity to produce five hundred barrels per year. After graduating from Chicago's Siebel Institute for brewing, Tim Kuss's

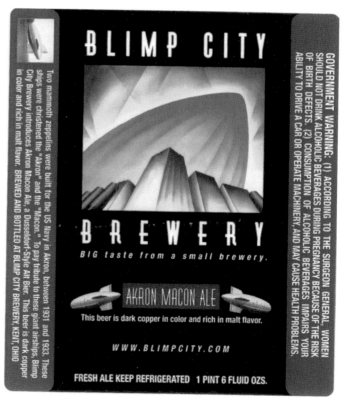

Above: The Northfield Park racetrack operated a small microbrewery at its site between 1998 and 2005. Several of its brands were available in bottles.

Right: The Blimp City Brewery operated in a small industrial park in Brimfield, near Kent, between 1998 and 2003. Its bottled beer was available throughout the area, including the Akron Aeros' baseball stadium in downtown Akron.

goal for the company was to start small and gradually grow as the brand developed a following in the area.

Having grown up in nearby Suffield, close to the Wingfoot Lake airdock (owned by the Goodyear Tire and Rubber Company), the Kuss brothers were used to the sight of blimps flying overhead on a regular basis, and therefore images of those were incorporated into many of the company's brands and graphics. Once in operation, four primary brands were produced: All-American Blonde Pale Ale, Blimp City Black Ale (a German-style schwarzbier), K-ship Kolsch (named after a type of blimp produced by Goodyear during World War II for patrolling America's coasts against submarines) and Akron/Macon German Style Alt Bier (named after two of Goodyear's giant airships, both built in Akron in the 1930s and both of which later crashed). Beer was sold in kegs to local bars and restaurants and was also available in twenty-two-ounce "bomber" bottles at selected retail outlets.

Brands were also produced for individual establishments, such as Ray's Place restaurant in Kent, for which Ray's Classic Ale was briefly bottled, and Delanie's Grille in Tallmadge, for which Blue Devil Blonde was bottled. Another limited brand, Aeros' Ale, appeared in 2000 for the minor-league Akron Aeros baseball team. Sales gradually grew as expected over the first four years of business, fueling speculation that Blimp City might finally open an associated brewpub or tasting room. However, as was the case with so many otherwise successful breweries of that era, the simultaneous economic downturn took a heavy toll on business. This, in combination with the cost of a new bottling line that had negatively affected the company's profitability, led to its closing and liquidation in February 2003.

Summit County's only early craft brewer to survive into the modern era was an extension of an establishment that had opened in Stark County in February 1997. At that time, the Thirsty Dog Brewing Company opened at 5419 Dressler Road, near the Belden Village Mall. After being established by a group of investors, the pub hired Fred Karm to be its brewmaster, overseeing operation of a ten-barrel J.V. Northwest brewing system that produced an impressive nine hundred barrels in its first year. A former electrical engineer, Karm had begun home brewing in 1994 and had quickly become obsessed with the hobby, so turning professional was an attractive option. He established all the recipes for a long lineup of beers and ales, most of which had canine names and many of which remain in production today more than twenty years later.

Success at the Stark County location led to the opening of another similar brewpub in Centerville, near Dayton, in 1998. That fall, a third site in

Thirsty Dog opened as a brewpub in North Canton in 1997; it later added sites in Copley Township and suburban Dayton before closing all three by 2005 in favor of its bottled beer business.

the chain opened in the commercial area known as Montrose in western Summit County (Copley Township), at 37 Montrose West Avenue. Again utilizing a ten-barrel brewing system, this site produced all of the same styles and names as its predecessors, with brewing still overseen by Karm. Among the many standard brands brewed were Old Leghumper Porter, Hoppus Maximus Ale, Siberian Night Russian Imperial Stout, Labrador Lager and Mixed Breed Black & Tan, and these were joined by a host of seasonal and specialty brews. Over the next few years, Karm accumulated a multitude of medals for his various brews from the Great American Beer Festival, the World Beer Cup and other competitions.

As early as 2000, owner Dale Magistrelli recognized the potential for sales of Karm's award-winning craft brews outside of the brewpubs. In that year, he purchased a recently closed microbrewery in Xenia, Ohio, for brewing and bottling of Thirsty Dog Beers and Ales, as well as some additional unrelated brands. For a variety of reasons, the timing wasn't right, and within two years, the project was scrapped in favor of maintaining the brewpubs. In 2003, the concept again saw the light of day, this time several hundred miles away in Frederick, Maryland. The Frederick Brewing Company began contract brewing four of the most prominent Thirsty Dog brands (Hoppus Maximus, Old Leghumper, Siberian Night and Balto Heroic Golden Lager), which were then shipped back to the Akron area for distribution throughout Ohio. Seeing more success with this portion of the business, Thirsty Dog's owners began closing the brewpubs one by one; the site in Copley closed in early 2005, the year that Akron's first wave

of craft brewing largely came to an end. Within a few years, however, the production end of the company would return to Akron as part of a new and highly successful phase of brewing in the Rubber City.

The Akron area's final new brewery of the millennium came to life in January 1999 and quickly became the shortest-lived of the group. Operating within the existing four-star Hudson Crossings Restaurant at 5416 Darrow Road in the city of Hudson, the Four Fellows Pub & Eatery used a ten-barrel Century

Coaster advertising Thirsty Dog's Balto Lager, used circa 2003.

brewing system with five fermenters and two keg lines, allowing seven beers to be on tap at the site at any given time. Overseen by California native Brad Unruh, the facility produced the typical offerings of the day: a pale ale, a cream ale, a brown ale, a porter and a light pilsner lager beer, with sales limited to the pub itself. While the concept of a brewpub within a restaurant was unique, it did not lead to long-lasting success, and the brewing facility had quietly closed by the end of 2000.

Each of the pioneer craft brewers of Akron opened with a splash, only to meet the same fate, one by one. Only the Thirsty Dog brand would manage to survive, although in a completely different format and with a new business model. The fate of Akron's early craft brewers, however, differed little from those of the rest of the state, and the reasons were largely the same. Of the eighty craft brewers that opened in Ohio in the 1990s, fewer than thirty were still open in 2005, and of those, fewer than twenty remain open today. While each one had its own story (bad business plans from the start, growing too fast and accumulating excessive debt, problems managing the restaurant side of the brewpub, bad luck in general and so on), they all suffered from two common issues. The economy in the early years of the millennium did not foster success for small businesses in general; the crash of technology stocks in 2001, followed closely by the 9/11 attacks, left the economy in the doldrums for the next two years. As a result, consumers were suddenly far less interested in spending extra money for luxuries like craft beer.

The other issue, which would ultimately resolve itself over time, was the public's overall acceptance of craft beer. In Ohio, the concept was still just over a decade old by the year 2000, and to many, it was still viewed as a novelty or a passing fancy. Conditioned by generations of advertising by the big national brewers, much of the public saw beer as a generic beverage, with the only variations being regular or light (low calorie); they were unaware of (and largely uninterested in) the many potential styles and flavor variations that beer had to offer.

While craft beers certainly could have disappeared altogether after so many early brewers failed, the opposite was actually the case. Thanks to the persistence of those brewers who survived the first wave of closures and continued to produce fine craft beers, as well as those who entered the field despite its inherent risks, the public continued to be exposed to an increasingly wide variety of styles and flavors of beer. Over the next decade, the old-school mindset of what beer was and what it should be would slowly change, allowing the craft brewing industry to be reborn and ultimately thrive.

CRAFT BREWING IN AKRON STARTS OVER

By 2005, just a few years after looking so bright and full of promise, the brewing scene in Northeast Ohio, and Akron in particular, again looked dismal. However, another rebirth was right around the corner; on September 1, 2006, the modern era of brewing in Akron began, headed by a familiar face to local beer enthusiasts.

Fred Karm had worked for Thirsty Dog during its brewpub days, establishing the recipes for the company's early brands such as Old Leghumper Stout, many of which went on to win national awards. When the chain of brewpubs closed, however, Karm was forced to look elsewhere for work. Although he considered opening his own brewpub, he chose instead to establish a production brewery in order to focus on brewing instead of food service. As luck would have it, he was able to purchase (at a substantial discount) the brewing equipment that he had formerly used at Thirsty Dog when its brewpubs were being dismantled; his familiarity with the system allowed him to hit the ground running with his new operation.

The name Hoppin' Frog Brewery was chosen as a play on the use of hops in the beer, in combination with his own nickname of "Frog." Occupying a space in a small industrial park at 1680 East Waterloo Road, his facility is within sight of the former Goodyear airdock, now owned by Lockheed Martin. After going into business for himself, Karm took an entirely different approach to commercial brewing, as he bucked several standard industry trends. His ability to think outside the box

At the Hoppin' Frog Brewery, labeling and filling the bottles is all done by hand. *Courtesy of Fred Karm.*

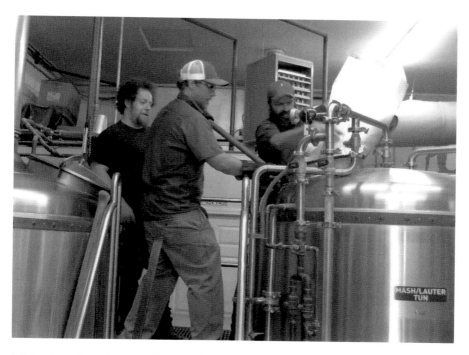

Mixing ingredients in the mash tun at the Hoppin' Frog Brewery. *Courtesy of Fred Karm.*

In the beginning phase of another batch of award-winning Hoppin' Frog Beer, the grains are mixed in the mash tun. The extract will later be boiled with hops and other ingredients in the brew kettle. *Courtesy of Fred Karm.*

has subsequently opened the door to many newer brewers who produce unusual beers for a select crowd instead of the masses.

Karm brought a strong sense of artistry to his brewing, producing beers and ales that were of a far higher alcohol content than was typical at the time. From the beginning, he took advantage of a state law, passed in 2002 despite vigorous opposition from Anheuser-Busch (which already recognized the potential threat that craft brewing posed to its business), raising the allowable alcohol percentage in beer from 6 to 12 percent by volume. Karm produced a wide variety of flavorful beers with high alcohol contents, most over 7 percent, all of which were sold in twenty-two-ounce bottles. Unlocking his potential further was another bill, signed in May 2016 by Governor John Kasich, that eliminated the cap on alcohol content altogether in Ohio.

Despite having thirty-two employees today, Karm still uses the same 10-barrel brewing system with which he started (with an annual capacity of 700 barrels at the outset). He has enlarged only to the point where he is using several additional fermenters, producing about 1,800 barrels per year,

Good times in the Hoppin' Frog Brewery tasting room, opened in 2013. Owner and brewer Fred Karm is at bottom left. *Courtesy of Fred Karm.*

although this number will soon be raised to about 2,700 per year. However, unlike many craft brewers who are aggressively trying to grow their businesses at the current time, Karm has no plans to expand the brewery significantly in the near future. The biggest recent addition was the opening of a large tasting room at the site in 2013 that features a small menu of sandwiches and other foods that go well with beer.

Considering the relatively low output, his area of distribution is one of the most remarkable aspects of the business, reaching twenty-three states from coast to coast and thirty-seven different countries (almost unheard of in the craft brewing world). Karm has won numerous awards over the years at the Great American Beer Festival, World Beer Cup and elsewhere for brews such as B.O.R.I.S., the Crusher Oatmeal Imperial Stout (which also has been rated as the top beer in Ohio) and Frog's Hollow Double Pumpkin Ale. Other creative styles are available as well, such as Barrel Aged Outta Kilter Scotch-Style Red Ale, Gangster Frog India Pale Ale, Karminator Imperial Dopplebock Lager and others. In June 2017, Karm released his Grapefruit Turbo Shandy (with 7 percent alcohol) in twelve-ounce cans for the first time; more cans and other types of packaging may follow in the future. His facility has been ranked by RateBeer.com as one

of the one hundred best breweries in the world for the past ten years, an impressive feat by any standard.

The Akron area's largest and longest-lasting brewery, with more than twenty years of continuous operation, is the Thirsty Dog Brewing Company. As we saw in the previous chapter, the company was established in 1997 as a trio of brewpubs in suburban Akron, Canton and Dayton. Once the company name had been established in its home market, several of its brands were contract-brewed and bottled in Maryland for distribution in Ohio. Even after the brewpubs closed in the mid-2000s, the bottled brands continued to appear in local stores over the next two years while the company was undergoing changes in management and in its overall structure.

John Najeway is one of four owners of the company (along with Clevelanders Ulo, Sue and V. Erik Konsen) and has been with it from the beginning. His background in home brewing, engineering and accounting have all served him well in successfully guiding the company through all the changes in the industry over the years. In August 2007, Thirsty Dog returned to brewing in Akron, but this time in the form of a production brewery, utilizing a fifteen-barrel system that had previously been used by the Brew Works brewery in Covington, Kentucky. The site of this new facility was immediately familiar to many Akronites, being in the former Burkhardt Brewery at 529 Grant Street, near the University of Akron. Initially utilizing a small portion on the ground level of the plant, the company has since expanded into several additional areas, including buildings that were previously dilapidated, with broken windows and graffiti-covered walls. The renovation of the old Burkhardt complex alone has been a tremendous success story for the city.

As plans for the new facility were being made, Najeway hired longtime brewer Tim Rastetter to return to Akron to oversee the project and serve as director of brewing operations. Rastetter had been in the craft brewing field from its earliest days, working at the Great Lakes Brewing Company and Akron's Liberty Street Brewing Company before working at Brew Works and then at the Hofbrauhaus brewery in nearby Newport, Kentucky. His return brought an expertise in craft brewing, which was a major factor in the company's later successes. The first brew to see the light of day at the new facility was traditional favorite and the company's best-selling brand, Old Leghumper Porter.

However, they soon began to add new brands and styles (all of which still retained dog-related names), such as Barktoberfest, Cerberus Belgian

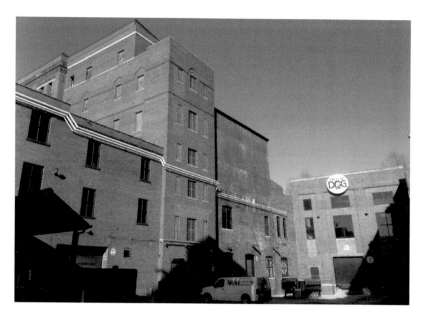

Thirsty Dog opened a new production brewery in Akron in 2007, utilizing a portion of the former Burkhardt brewery on Grant Street.

The fifteen-barrel kettle at the center of the Thirsty Dog brew house, where three batches are brewed every day.

Trippel and 12 Dogs of Christmas Ale, which has since become a seasonal favorite. A decade later, the list of brands that have been made by Thirsty Dog is too long to recount. In 2010, the company opened a new area devoted to barrel-aged beers, made in small quantities and sold in larger 750mL bottles. In this area, several hundred bourbon and wine barrels are stacked to the ceiling, holding brews such as Wulver Wee Heavy Ale (with 12 percent alcohol), Siberian Night Imperial Stout and others. The company's motto had always been "Unleash the flavor," and now more than ever, it was getting an opportunity to do just that.

In 2008, the company began contract brewing for a group of investors that wanted to focus a brand of beer around the University of Akron's mascot, a kangaroo named "Zippy." Bottles of Roobrew Litigation Lager subsequently appeared intermittently in area stores over the next few years. Thirsty Dog also produced several Akroncentric brands under its own name, such as Rockweiler Ale for radio station WONE 97.5 FM, Beacon Brown Ale for the 175th anniversary of the *Akron Beacon Journal*, Rail Dog Lager for the Cuyahoga Valley Scenic Railroad, Magic City Ale for the city of Barberton's 125th anniversary and more.

Najeway has proven to be a master at public relations and marketing, strengthening his company's name recognition at every opportunity. He established the Blues & Brews Brewfest in 2005, where Thirsty Dog beers were made available to the public for sampling along with those of other area brewers. Initially held at Stan Hywet Hall & Gardens, it is currently held every August at Lock 3 Park in downtown Akron. Now the oldest brewfest in Ohio, it has selections from nearly eighty craft brewers, twenty-six of which are in Ohio. He has also established collaborative events with the Akron Art Museum and other selected sites in the area.

As of 2017, the company has thirty-five employees, brewing three batches of beer per day, seven days a week, and producing roughly twenty-two thousand barrels of beers and ales per year. These are sold in fifteen different states, with more in the works. Despite this, Najeway has no intention of expanding to national distribution, preferring instead to remain east of the Mississippi River. Rastetter was eventually succeeded as head brewer by Adam Stull and, more recently, by Brandon Benson. As India pale ales have come to the forefront of craft brewing over the past decade, reflecting a shift in the public's tastes, Citra Dog IPA has become the company's best-selling brand as of this time. While twelve-ounce bottles remain the standard of packaging for the company, it is considering the possibility of canning some brands at some point in the future.

Several hundred batches of Thirsty Dog barrel-aged brews are aging at any given time.

Never content to rest on its haunches, Thirsty Dog opened a twelve-thousand-square-foot brewpub in Cleveland's Flats district, along the east bank of the Cuyahoga River, on October 25, 2017. Equipped with a ten-barrel brew house, the restaurant, taproom and patio is the company's first foray into food service in more than a decade. It will also put it just down the street from Cleveland's Collision Bend brewery and a short distance from several brewers in the Ohio City region, including the granddaddy of them all, Great Lakes. From a brewing perspective, this will be the first direct connection between Akron and Cleveland in history, and it could very well be a sign of more great things to come.

The next brewery to appear in the Akron area met with far less success than the previous two, although it broke new ground for Summit County. Known as the Beer Factory, it was neither a brewpub nor a microbrewery; it was a BOP, or brew-on-premises establishment. A concept that first developed in Canada during the 1980s, a BOP allows the public to use its equipment to brew and bottle their own beer from a predetermined set of recipes. Opening in 1995 in Strongsville, just southwest of Cleveland, the Brew Kettle was not only Northeast Ohio's

Cartons of bottles are stacked to the ceiling in the Thirsty Dog warehouse, which utilizes the former Burkhardt power plant building.

first BOP but also its most successful one. After studying at Chicago's Siebel Institute of Technology, Brian Caton worked as an assistant at the Brew Kettle before deciding to bring the concept south to Copley Township, just west of Akron.

Opening in 2008 in a former supermarket at 2799 Copley Road, the Beer Factory shared its space with a separate business known as It's Your Winery, where, not surprisingly, patrons could make their own wine. Caton followed the basic model he had learned in Strongsville, offering more than fifty recipes, along with six half-barrel brew kettles and ingredients, to willing customers. After the first brew would take place, the beer or ale would be given several weeks to age before being bottled. In the end, one batch would yield seventy-two custom-labeled twenty-two-ounce bottles (slightly more than twelve gallons) of beer, for a price ranging between $115 and $165. Caton also sold his own craft brewed beer in bottles and on draft at the on-site bar. Unfortunately, the small establishment was not widely advertised, and although the demand was

present, the company had closed its doors by the end of 2009, bringing a quick end to the BOP chapter of Akron's brewing history.

Finishing out the first decade of the new millennium was the arrival of a survivor from craft brewing's first era, though still a newcomer to Akron. The Ohio Brewing Company had been established in 1997 in Niles, Ohio, an hour east of Akron. Established by brothers Michael and Chris Verich, the company operated in a brewpub format for the first two years, using a ten-barrel system to brew several beers such as Verich Gold, Cardinal Ale and Steel Valley Stout. Michael Verich, a Warren attorney, had been an elected state representative for many years before taking a permanent government job in 1998, with his elected position being filled by Chris for the next two years. With the brothers having less time to devote to the business, the restaurant operation was sold, leaving the microbrewery intact to brew beer for bottling and distribution through the area.

In 2002, the brewing operation was moved to a renovated former B&O Railroad station in downtown Youngstown, still operating as the Ohio Brewing Company. However, the facility was sold after several months, as the Verich brothers had their sights set on moving operations to the larger market of Akron. Several years passed, however, before a new facility, with all-new brewing equipment, finally opened in 2008, in the former O'Neil's department store building at 222 South Main Street in the heart of downtown. Built in the 1920s, the huge building was a major landmark in the city, even after its closing in the 1980s. It was hoped that the brewery, which partnered with the well-established Damon's Grill to provide food service, would help to bring people downtown, especially with the Akron Aeros baseball team playing just a block away. However, trying to establish itself in a new market during the recession of 2008 spelled doom for the company, and by the end of 2009, it had quietly closed its doors.

Not giving up, Chris Verich returned to the pure microbrewery format one year later, opening a production facility on the south side of downtown in the century-old, former Selle Generator Works complex at 451 South High Street. Using a fifteen-barrel brewing system with an annual capacity of one thousand barrels, he continued to brew the same basic lineup of styles, such as Verich Gold, Cardinal Ale, Alt-ernative Amber and O'Hoppy Ale. However, he was now able to bottle them for distribution throughout the region, which had always been a major goal. By 2013, this facility had closed, although the Ohio Brewing Company

name remained on store shelves in the area thanks to contract brewing through various Ohio craft brewers. Most recently, Verich has used Cleveland's Platform Brewing Company to brew and bottle his brands for retail sales.

Meanwhile, the Ohio Brewing Company reappeared at yet another site in 2015; this time, Verich returned to the brewpub format, opening at 804 West Market Street in the city's Highland Square district. An eclectic but pleasant neighborhood of older, stately homes mixed with apartments and scattered green spaces, it has been a popular area for the city's younger population for many years. The new Ohio Brewing Company fit right in with a friendly "corner tavern" atmosphere. The seven-barrel brewing system was in a back room, visible from the small bar area through a window; eight of the company's brands were available on tap, with another twenty craft beers from other brewers available as well.

In October 2017, however, Verich abruptly put the site up for sale, as he wanted to expand again. The new owners, operating as the Barmacy Bar & Grill, had not yet determined the fate of brewing at the site as of this writing. Meanwhile, Verich purchased a much larger site at 2250

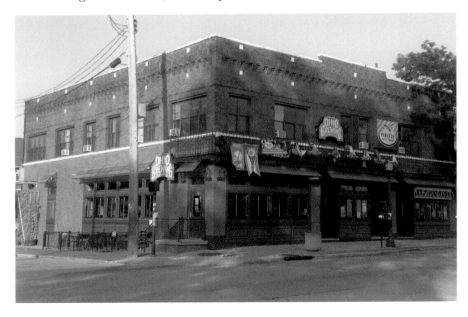

The Ohio Brewing Company operated from 2015 to 2017 in the Highland Square district in West Akron.

Front Street in Cuyahoga Falls, where he intends to open up again with a new brewing format in 2018. Having brewed professionally for twenty years, he continues to seek out the perfect balance of size, location and food service and hopefully will remain a part of Akron's beer culture for years to come.

CRAFT BREWING IN AKRON TODAY

With three sizeable craft breweries operating successfully in Akron as of 2010, it appeared that the local industry had stabilized and would continue as such for the foreseeable future. However, no one could have predicted the explosion of small craft brewers that occurred over the next few years as the public began to focus on locally made beers. At the same time, the concept of a nanobrewery (a facility with a brewing system of four barrels or less) became increasingly popular; being much smaller than traditional brewing systems, these were far more affordable. This combination allowed many new players to enter the picture over a fairly short period of time, as the dynamics of the area's beer market changed dramatically yet again.

One of Akron's first nanobreweries to open its doors was the Aqueduct Brewing Company, which appeared on the scene in October 2014. Owned by home brewers Robert and Sara Hernandez, Aqueduct utilizes a two-barrel brewing system to produce a rotating variety of ten beers, all of which are available on tap at the site, as well as in half-gallon growlers for takeout.

The brewery and its tasting room occupy a small space in the rear of the huge complex at 529 Grant Street, formerly housing the Burkhardt Brewing Company (although Aqueduct is adjacent to the Thirsty Dog Brewery, the two companies are unrelated). With the Hernandezes' love of history, the building's century-old character plays a large role in the pub's ambience. Its new restrooms have been built in the basement in a room next to one of Burkhardt's original stone-lined cellars, which has four feet

In the basement of the Aqueduct Brewery is a century-old stone-lined aging cellar, used by Burkhardt as early as the 1870s.

of water in it at all times from long-buried Wolf Creek. Another adjacent room where Burkhardt's cistern (providing early access to the creek's water) is located has recently been renovated and will provide additional space to be used for events.

The Hernandezes have brought to fruition many of their initial plans for the brewery, including brewing lessons for the public, with advanced learners being able to utilize the two-barrel professional system. A brew-on-premises operation at the site is also up and running. Sara's next plan for the future is to establish a Women in Brewing group, which will begin holding meetings at Aqueduct. The goal of the group, made up of many of the other female brewery owners in the Akron/Cleveland area, is to increase the number of women beer drinkers and assist female brewers and brewery owners. Sara hopes that the group will eventually expand to include any local women who make their living in some way from craft beer. With a vast amount of space still unused in the old brewery, the company's possibilities are endless.

Also joining the crowd of Akron's brewers are Joshua and Nicole Bringman, who opened the Brick Oven Brewpub in December 2014.

Operating at 604 Canton Road in the city's Ellet district, the restaurant focuses as much on its wide variety of hand-crafted pizzas (all cooked in the huge homemade brick oven) as it does the beer. Joshua had been a home brewer for nearly a decade before investing in a one-barrel Psycho brewing system, producing several styles (cream ale, oatmeal stout, IPA, Belgian-style wit and others) that are on tap in the pub. No bottling or outside distribution is done at this time, but the combination of pizza and beer has quickly spelled success for the couple.

Craft brewing returned to the Merriman Valley district north of downtown in September 2015 with the opening of R. Shea Brewing at 1662 Merriman Road in a small strip plaza. Owner, brewer and native Akronite Ron Shea has degrees in biology and chemistry and worked in research and development with a major chemical company for many years before undergoing a dramatic career change. Having home brewed for nearly twenty years, he applied his scientific background to the art when

he turned professional. Utilizing a 3.5-barrel brewing system, Shea actually began brewing well in advance of the public opening of his large taproom, and as a result, he was able to have twelve different beers on tap at the time. He brews a wide variety of styles, from light-bodied wheat beers with peach or blueberry flavor ("good while mowing the lawn") to session beers and unique combinations such as a coconut rum coffee stout. In addition to sales in the pub, he also sells draft beer through several local stores. In late 2016, food service was added to the pub.

As business has continually increased since his opening, Shea is currently working on the construction of a much larger production brewery in downtown Akron, at the Canal Place complex that formerly housed the B.F. Goodrich rubber factory. Reportedly costing $2.7 million to build, the new site will house a twenty-barrel brewing system and will include an eight-thousand-square-foot tasting room and restaurant when it opens in 2018. Shea envisions the establishment of an Akron

Several R. Shea brands of beer are available at the brewpub for takeout, in thirty-two-ounce aluminum "Crowlers."

At the R. Shea Brewery on Merriman Road in the Cuyahoga Valley, the brewing system stands immediately behind the bar, creating an intimate environment for patrons. The pub is full most nights.

Brewery District similar to ones created in Columbus and Cincinnati; six craft brewers are currently either open or in the construction phase in Akron's downtown area as of this writing. Between his extensive scientific education, willingness to work hard and creative thinking, it already seems well assured that Shea has a bright future in the city's brewing culture.

As the first brewery to open in the Portage Lakes area south of Akron, the Mucky Duck Brewing Company operates in a shopping plaza at 4019 South Main Street. Joe and Erica Wathey opened the Nauti Vine Winery in 2013 across the road, and shortly thereafter, they established a small nanobrewery in the basement of that site, brewing twenty gallons per batch. The demand for their beers was great enough that they expanded to the current site in April 2016, with a larger five-barrel brewing system surrounded by a spacious, attractively decorated pub. Brewer Cody Cantrell produces twelve different brews, mostly ales, all of which are on tap in the pub; in addition, a small amount is bottled for sale in nearby stores and restaurants.

Opening in September 2016, the Two Monks Brewing Company is the brainchild of longtime home brewers Patrick Armstead and Steve Prough. Located near the new Goodyear world headquarters at 352 Massillon Road,

their nanobrewery utilizes a half-barrel brewing system, with a small tasting room at the site as well. The partners' goal is to produce "craft beer for the masses," which means producing a wide variety of styles that stick to their standard definitions without a lot of "goofy stuff" added in. Initially, there will be no outside distribution or bottling, but eight styles (IPA, blueberry ale, Irish stout and more) are available on tap at the pub, which they hope to expand over time.

Three additional breweries are in the construction phase as of this writing and will likely be open by the time this book is in print. Akronym Brewing LLC will be located in a city-owned commercial space that is part of a parking deck at 58 East Market Street. Founders Shawn Adams, Josh Blubaugh and Aaron Cruikshank are home brewers who bring a great deal of experience to this new venture, and their goal is to produce award-winning, high-quality beers. Their ten-barrel production facility will enable them to have up to twelve beers on draft in their tasting room, where most of their sales will take place.

Farther north will be the Lock 15 Brewing Company, adjacent to the Ohio & Erie Canal and its towpath, in the Little Cuyahoga River Valley. The brewery will be located in the Cascade Lofts, an apartment complex in the renovated Swinehart Rubber Company building, more than a century old, on the northwest corner of North Street and North Howard Street. Owned and operated by Colin Cook, the brewery will be connected to an outdoor beer garden as well. With more breweries in the planning phase already, there will undoubtedly be additional craft brewers calling Akron their home within the next few years.

Most recently, it was announced that the Missing Falls Brewery would also be opening in the century-old Canal Place complex (near the new R. Shea production brewery), on South Main Street. Originally planning to open a small nanobrewery in suburban Munroe Falls (hence the company name), the brewery's owners encountered difficulties with their chosen location, leading to the move to a larger venue with more exposure at Canal Place. The new site will house a seven-barrel brew house and a sizeable tasting room. Owners Mark Crnjak, Will Myers, Sean Hamilton and Kenny Davis will bring their home brewing experience to the new facility, with six or eight styles available in addition to rotating seasonal options.

Looking several miles north of Akron in Cuyahoga Falls, the HiHo Brewing Company opened on January 6, 2017. Located in a former car showroom at 1707 Front Street, the site overlooks the Cuyahoga River gorge. Jon and Ali Hovan, natives of Hudson, spent well over a year putting

the facility together after returning from several years in Colorado, where they developed an appreciation of craft beer. Their seven-barrel brew house overlooks the bar area, which was completely full of patrons when the author visited the brewery on a pleasant April evening just three months after it had opened. Trimmed in bright yellow, the bar has eight different brews available along with snacks and sandwiches. Surrounded by windows, the pub has a wide-open feel and has quickly become a very popular site in the city—so much so that the Hovans acknowledged that they had reached their five-year goal in just the first six months, allowing them to add more fermenters to triple the brewing capacity.

Also in Cuyahoga Falls is McArthur's Brew House, which opened in March 2017 at 2721 Front Street. Established by the husband-and-wife team of Kevin and Abbey McArthur, the site has a two-barrel nanobrewery, which yields five brews to be on tap at the bar at any given time. At this time, they do not feature food service but may open a beer garden at the site, along the Cuyahoga River, in the future. Initially, beers will not be distributed elsewhere, but that could change over time as well.

Suburban Akron will soon be awash with craft brewers, with several more set to open in the latter half of 2017 or beyond. The city of Stow will be

Canal Place, formerly the B.F. Goodrich tire company's world headquarters, is a massive century-old complex just south of downtown Akron. Used now for office space and as a business incubator, it will house two separate craft brewing facilities, Missing Falls and R. Shea, by 2018.

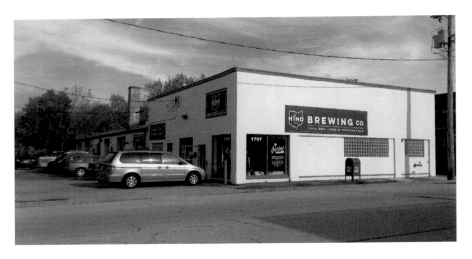

The HiHo Brewing Company opened in 2017 on Front Street in Cuyahoga Falls, one of a growing number of suburban brewpubs in Summit County.

represented by the Headtrip Brewery at 1634 Norton Road. Owners Nick Seagle and Tom Mitchell have a three-barrel nanobrewery that will produce a rotating variety of brews to be sold at a small on-site bar.

In October 2017, the city of Hudson celebrated the opening of a branch restaurant of the Brew Kettle chain at 11 Atterbury Boulevard in the downtown district. Owned and operated by Chris Russo, the company first opened in Strongsville in 1995 as a brew-on-premises operation, with a small microbrewery and restaurant. Since then, its own brands have grown in popularity to the point where a separate production brewery is being added. Its original restaurant has been wildly popular, leading to branches opening in Amherst and elsewhere. Employing forty people or more, the new Hudson facility will feature its own small brewing system, although most beers served there will be made at the Strongsville location.

Meanwhile, three miles south, the Hop Tree Brewing Company was on the verge of opening as this book was being completed in the fall of 2017 at 1297 Hudson Gate Drive. Founders Cory Ross and Greg McClymont have been planning this project for more than a decade. Roughly $700,000 has been invested in a ten-barrel brewing system that will yield a lineup of brews to be served on-site, with an adjacent tasting room as well.

On the opposite side of the county, the city of Barberton will soon be home to two breweries. The Magic City Brewing Company will operate at 161 Second Street Northwest. Owners Jay and Erica Graham will have

a small brewing system, three barrels or less in size, and will try to have as many as eight of their beers on tap at the site. In 2016, the couple raised more than $20,000 through Kickstarter to help fund the project. Also coming soon is the Ignite Brewing Company, located a block from Lake Anna at 600 West Tuscarawas Avenue. The product of three couples—Jason and Megan Slater, Michael and Stacy Chisnell and Adam Reinhart and Marie Bruening—the facility will have a seven-barrel brewing system and a large tasting room. The company's name is an indication of the group's desire to spark new growth in the working-class city, as well as being a tribute to city founder O.C. Barber, who established the Diamond Match Company there. Beers will be sold at the bar instead of being distributed elsewhere.

Thus far, the only brewery in Greater Akron to close since 2010 is the Trailhead Brewery, the city's first nanobrewery, which opened in 2013. Located at 1674 Merriman Road, it was adjacent to both the Ohio & Erie Canal Towpath Trail and the Sand Run Metropark, thus inspiring the name. Proprietor Eli Smart operated a one-barrel brewing system with a small taproom at the site and quickly developed a sizeable following. However, he closed the small facility in November 2015, not due to any lack of success but because his wife had received a promotion in her own career, leading to their move to California.

In addition, brewing in Greater Akron is no longer limited to Summit County. In Medina County, Lagerheads Brewery opened as a restaurant in 2004 at 2832 Abbeyville Road, several miles north of Medina. In 2010, a small brewery was added to the site, but its popularity grew so quickly that the brewing operation was moved in early 2015 to a new production facility in downtown Medina, at 325 West Smith Road. Also featuring a tasting room, the new site allows for the canning of Lagerheads beers. More recently, the Wadsworth Brewing Company opened in January 2017 at 126 Main Street, owned by Ernie Joy and Ericha Fryfogle-Joy. In Wayne County, the JAFB Wooster Brewery opened in 2012, seeing immediate success.

In Portage County, the Madcap Brewing Company operates at 1422 Mogadore Road in Kent. First opening in 2013 as a tiny nanobrewery in a garage in the town of Stow, it later expanded to a three-barrel brewing system before moving to its current location in 2016. Now using a ten-barrel system, owner Ryan Holmes oversees production of the Bullet IPA, 20 Eyes Pale Ale, Gold Flash Golden Ale (named for the Golden Flashes, the Kent State University sports program) and a host of other specialty brews. A taproom has been added at the new facility, elevating the public profile of the brewery considerably.

The ten-barrel brewing system of the Madcap Brewing Company, which started in 2013 as a tiny nanobrewery in a garage in Stow and has recently moved into a much larger facility in Kent.

Meanwhile, the Greater Cleveland area has more than thirty operating breweries as of this writing, ranging from multiple tiny nanobreweries to the huge Great Lakes Brewing Company. The latter, currently producing more than 160,000 barrels per year (comparable to Akron's Burkhardt Brewery at its peak in the 1950s), is the nation's twenty-first-largest craft brewer. Moving south of Akron, the town of Hartville has Maize Valley, a unique combination of farmers' market, winery and craft brewery. The Scenic and Royal Docks Brewing Companies operate in suburban North Canton, while downtown Canton has the Canton Brewing Company, a large new restaurant that focuses heavily on the city's long brewing history.

Overall, Northeast Ohio has more than 70 operating breweries at this time, while the state of Ohio has well over 200, with many more in the planning or construction stage. It is reasonable to think that there will be more than 300 breweries statewide within a short time. Nationwide, the number of breweries topped 5,300 in 2016, the largest number ever; what a far cry this was from the industry's nadir in 1978, when a mere 89 breweries were in operation nationwide! In the pre-Prohibition era, the largest number of registered breweries was 4,100, seen in 1873.

Looking at the industry's history and seeing all of these recent entries into the brewing world, the question is often raised of whether the market has reached a saturation point, as well as how many of these breweries can survive long term. Opinions vary widely, with some feeling that the market has been saturated for some time and others feeling that the local market can support far more growth. Of course, only time will tell, but based on the first wave of craft brewing, one would naturally tend to view the situation with pessimism. However, there are several key differences between that first wave and today, providing many reasons to remain quite optimistic.

Craft brewing is now an accepted and treasured part of modern American culture; one look at the beer section of most grocery stores confirms this fact, with a huge variety of brews available from all over the country. The many subtle variations in beer flavor, aroma, texture and other aspects are often analyzed and discussed in a similar manner to that of fine wines. In the 1990s, many people who grew up in an era when cheap national brands cost less than two dollars for a six-pack would never have considered spending the higher prices that craft beers typically command. Today, few craft brew enthusiasts hesitate to pay eight to ten dollars per four-pack, with some specialty brews commanding well above ten dollars per bottle. The days are gone when Americans were brainwashed by mass marketing into thinking that beer was a singular beverage, narrowly defined by large national brewers as a light-bodied drink with a relatively low alcohol content. The public's modern appreciation of fine beer will ultimately maintain the craft brewing industry, providing a demand that will not likely fade over time.

In addition, the economic impact of beer is now well recognized. As of 2017, it was estimated by the Beer Institute (a Washington lobbying group for the industry) that Ohio's brewing industry supports more than forty thousand jobs, with a combined economic impact of $13 billion, ranking it seventh nationwide. Statewide, $2.5 billion is generated annually in tax revenue. Each job in an Ohio brewery was estimated to impact forty-five additional jobs in agriculture, retail, business services, distribution and tourism. Nationally, the industry has an economic impact of $350 billion, while supporting more than 2.2 million jobs. Craft brewed beers represented 22 percent of the United States' beer market in 2016, more than twice what it was just four years earlier, a remarkable trend. Even the home brewing industry has grown, likely inspired by the professional craft breweries. More than 1 million Americans brew beer at home and are well versed on the technical and chemical aspects of the process; most of the area's professional craft brewers started out as home brewers.

Reflecting Northeast Ohio's fascination with craft brewing, it has been strongly supported by the area's newspapers, with the *Akron Beacon Journal* featuring a large weekly column by noted writer Rick Armon, who also maintains an online beer blog and a frequently updated map of all breweries in Ohio (a valuable tool for the rapidly changing industry). All new breweries are noted, along with expansion projects, new brands, brewing festivals and tastings and other beer-related news. Similarly, the *Cleveland Plain Dealer* features beer news written by Marc Bona. Local grocers such as Acme Fresh Markets, Giant Eagle, Buehlers and others have expanded their beer sections to include large varieties of craft beer, particularly those made in Ohio.

The region has also seen an increase in tourism related to craft brewing, as beer connoisseurs from across the country visit the area's brewers to sample their products and experience each individual site. For many of these people, the visits are about the ambience and social aspects of the brewpub "experience" as much as the beers themselves. In response, the Akron/Summit Convention & Visitors Bureau created the Summit Brew Path in early 2017, featuring a "passport" with which beer drinkers could visit fourteen different breweries in the four-county area, receiving a stamp at each site. Upon completion, they would receive a T-shirt reading, "I completed the Summit Brew Path," as well as being entered into a drawing for a grand prize of an Akron getaway. The response was overwhelming, with the first ten thousand passports being given away in roughly two months. Akron's brewers were delighted, as it brought them a great deal of unexpected business, thereby achieving its goal. Shortly after this, the Ohio Craft Brewers Association launched a statewide passport app for smartphones, looking to accomplish the same thing on a larger scale.

While the early craft brewers were largely finding their way through the darkness alone, learning many hard lessons in the process, current brewers have a huge advantage in being able to look back at the experiences of those who have come before them, seeing what went right and what went wrong during the early days. More effective business plans are typically seen today, with investors being lined up for large projects (a ten-barrel brewing system can cost more than $1 million to establish), or, if investors are not an option, starting as a nanobrewery with an investment of less than $100,000. Another common trend among early craft brewers was the perceived need to incorporate full-scale food service, with which they often had little to no experience and which created a far greater level of debt from the start, into their brewing facilities. Today, smaller-scale tasting rooms, with menus limited to snacks and appetizers (making them far more cost effective and

easier to manage), are more typical of craft breweries, allowing them to focus on brewing.

Modern brewers have also found that more interaction and communication among themselves has been highly beneficial to all. Unlike most industries, where competition is viewed as a threat, the craft brewing industry is just the opposite, with an approach described by some as "the more the merrier." This approach has thus far proven accurate, as the increased number of brewers has given consumers far more options than ever before, leading to more media coverage, more awareness of the industry in general and more of the public turning to craft beers.

Along those lines, the Ohio Craft Brewers Association was formed in 2008 with the following goals: to unify the Ohio brewing community, market Ohio-manufactured beers throughout the state and beyond, monitor and promote a strong beer industry in Ohio and organize statewide events that showcase the state's brewing industry. This has led to a seemingly endless list of brew fests and beer tastings throughout the Akron area and across the state. The association's officers are all craft brewers from around the state. Helping the cause are key members of the local brewing community, such as John Najeway and Fred Karm, who have a particular knack for public relations. Both have been instrumental in helping to establish their respective brands (Thirsty Dog, Hoppin' Frog) as household names and making the general public more aware of craft brewing.

While the success of most 1990s brewpubs depended entirely on beer sales within their restaurants or bars, the networking of modern craft brews allows many to be sold over a wide geographic area, with greatly improved name recognition (aided significantly by the industry's strong Internet presence) and a greater opportunity to generate revenue on a continuing basis. The canning of beer, once felt to be unthinkable for the craft industry, can now be easily added to even the smallest brewer's operation, providing another option for consumers. Small, permanent canning lines are more affordable today than in the past, and mobile canning services are also available, providing an even more cost-effective option. Canning has proven to be particularly advantageous for craft brewers, as it prevents light from aging the beer prematurely, extending its shelf life significantly. Since craft beers tend to move off the shelves more slowly than high-profile national brands, this allows them to remain on display far longer without spoiling.

In the past five years, canned craft beers have evolved into their own unique art form, with a wide variety of designs and brand names to go with the variety of beer styles now available. Literally as this paragraph was

being written on June 22, 2017, Hoppin' Frog became Akron's first craft brewer (and the first brewer of any type since 1964) to release its beer in cans. Utilizing a mobile canning service, its Grapefruit Turbo Shandy, with an alcohol content of 7 percent, was released in twelve-ounce cans. Available just during the summer, the brand competed with national brand Leinenkugel and others in the rapidly growing fruit-flavored beer market. Fred Karm stated that while he is testing the market at this time, more of his brands may be canned in the future. Regardless, it is highly likely that other local brewers will soon be adding canned beer to their output.

The city of Akron will celebrate its 200th birthday in 2025, and as that date rapidly approaches, the city's craft brewing industry (nearly thirty years old itself) is as vibrant and sustainable as it ever has been. The 2010s have been a period of phenomenal growth in the field, both locally and nationally, as well as an exciting time with an unleashing of brewing as an art form, allowing for a seemingly endless potential to stretch the limits of how beer can be defined. For all the ups and downs that both the city and the local industry have experienced over the years, the foreseeable future is bright for both brewers and beer drinkers in the Rubber City!

INDEX

A

Adams, Shawn 130
Aiken Bill 67
Akron Beverage and Cold Storage
 Company 60
Akron Brewing Company (1934)
 85
Akron Brewing Company, The 25,
 43, 52, 53, 54, 55, 56, 57, 58,
 59, 60, 63, 65, 72, 85
Akron Burkhardts 50, 92
Akron Pros 50
Akronym Brewing 130
Anti-Saloon League 33, 67
Aqueduct Brewing Company 100,
 126
Armon, Rick 136
Armstead, Patrick 129

B

Banner Beer and Ale 94
Barberton 27, 76, 89, 120, 132
Beer Factory 121, 122
Benson, Brandon 120
Bittman, Michael 22
Blimp City Brewery 108
Blubaugh, Josh 130
Blues & Brews Brewfest 120
Bona, Marc 136
Brew Kettle, the 121, 122, 132
Bringman, Joshua and Nicole 127
Bristol, F. Charles 86
Brodt, John 28
Burger Brewing Company 96, 97
Burkhardt Consolidated Company
 71, 81, 94
Burkhardt, Gus, Jr. 95, 96
Burkhardt, Gustav F. "Gus" 40, 81,
 82, 92

Burkhardt Insurance Company 95
Burkhardt, Margaretha 40, 41, 47, 71
Burkhardt Realty Company 47
Burkhardt's Custom Inn (radio program) 92
Burkhardt, Thomas 96, 104
Burkhardt, Tom 97
Burkhardt, Tom, Jr. 105
Burkhardt, Wilhelm 39, 40
Burkhardt, William 71, 88, 92, 96, 97, 104
Burkhardt, William G. 82
Burkhardt, William, Jr. 96, 97
Burkhardt, William L. 41

C

canned beer 79, 90, 94, 138
Cantrell, Cody 129
Carmichael Construction Company 86
Cascade Lofts 130
Caton, Brian 122
Ciriello, Joseph 97
City Ice & Coal Company 47, 71, 95, 96
Clarkson, Joseph 26
Clark's Tavern 17
common beer 19, 20, 21, 22, 24
Cook, Colin 130
Crosby, Dr. Eliakim 16
Crowntainer 79, 90
Cruikshank, Aaron 130
Cullen-Harrison Act 76
Cuyahoga Falls Brewery 27

D

Dahlgren, Chuck 105
Deibel, Ernest C. 32, 36, 70, 89
Dettling, Jacob 60
Dettling, Louis 59
Diamond Land and Improvement Company 63
Dietz, Carl 71
Dippel, George 82, 97

E

Embassy Club Beer and Ale 94

F

Fink, Conrad 24
Forge Industries 92
Fornecker, Jacob 38
Four Fellows Pub & Eatery 112
Frederick Brewing Company 112
Fritch, Martin 42, 71
Fuchs, F. William 55

G

Gaessler, Frederick 38, 39, 40
Gayer, Jacob 71
Giessen, Otto 38
Good, Jacob 22
Good, John T. 21
Goosetown 20, 40
Graham, Jay and Erica 132
Graybill, Chuck 106

Great Lakes Brewing Company 104, 118, 134
Grossvater Beer 33, 68, 76, 79, 86, 89, 90
Gruner, Walter 60
Gunn, David 108
Guth, Jacob 22

H

Hafenbrack, Ernst 60
Harmann, George 28
Hau, John 57, 60
Hausch, A.J. 98
Headtrip Brewery 132
Hernandez, Robert 126
HiHo Brewing Company 130
Holland, Robert F. 89
Holmes, Ryan 133
Hoppin' Frog Brewery 114
Hop Tree Brewing Company 132
Horix, Fred 26, 28, 53, 55
House of LaRose 86
Hovan, Jon and Ali 130
Huster, W.J. 97

I

Ignite Brewing Company 133
Illenberger, Max 79, 89
Iredell, Seth 16

J

James, Carl 92
James, C. Gilbert 90

K

Karm, Fred 110, 114, 137, 138
Kempel, George 28
Kirn, John 25
Koerber, John 55, 59
Kolp, John 29
Konsen, V. Erik 118
Koons, J.F. 97
Kraatz, Charles A. 86
Kuss, Mark 108

L

Lagerheads Brewery 133
Lamparter, John 55
Lane, Sam 66, 67
LaRose, Tom 86
Leisy Brewing Company 86
Liberty Brewing Company 106
Lock 15 Brewing Company 130
Lockert, Jacques 24

M

Madcap Brewing Company 133
Magic City Brewing Company 132
Magistrelli, Dale 112
M. Burkhardt Brewing Company 38, 39, 40, 41, 43, 44, 46, 47, 50, 51
McArthur, Kevin and Abbey 131
McArthur's Brew House 131
McClymont, Greg 132
Middlebury 15, 16, 24
Mitchell, Tom 132

Mucky Duck Brewing Company 129
Mug Ale 82, 94, 96, 97, 105
Mulcahy, John J. 86

N

Najeway, John 65, 118, 137
nanobrewery 126, 129, 130, 131, 132, 133, 136
Nation, Carry 67
Neubauer, Carl 97
Norka 71
Northfield Park 107

O

Oberholtz, Christopher 29
Ohio Brewing Company 123, 124
Ohio Craft Brewers Association 136, 137
Ohio & Erie Canal 15, 21, 130, 133
Old Cockney Ale 79
Old Gross Half and Half 79
O'Neil, Rory 106, 107

P

Paquin, Jacob 71
Pennsylvania & Ohio Canal 27, 28
Perkins, General Simon 16
Prough, Steve 129

R

Rastetter, Tim 106, 118
Renner and Weber Brewing Company 31
Renner, Bob 90
Renner-Deibel Oil & Gas Company 36
Renner, George J. 31, 36, 70, 76, 89, 90, 91, 92
Renner Products Company 70, 76
Renner, William 70
Roobrew 120
Roosevelt, Franklin 75, 88
Rose Law 67
Ross, Cory 132
R. Shea Brewing 128
Russo, Chris 132
Russo, David 106

S

Seagle, Nick 132
Seesdorf, Philip 26
Selle Generator Works 123
Sellinger, Frank 97
Shea, Ron 128
Smart, Eli 133
South Akron Brewery 24
Souvenir Beer 79
Specht, Charles W. 27
Stull, Adam 120
Summit Brew Path 136

T

Tasty Pure Food Company 63
Thirsty Dog Brewing Company 65, 100, 110, 118
Tiro 63
Trailhead Brewery 133
Tudor Beer and Ale 94
Two Monks Brewing Company 129

U

Uniontown 26
Unruh, Brad 113

V

Verich, Chris 123
Verich, Michael 123
Viall, Marshall 24

W

Wadsworth Brewing Company 133
Wathey, Joe and Erica 129
Weber, Henry 31
Weber, Otto 73
Weiner, Anthony 89
weiss beer 27
Wheeler, Wayne 67
White Crown Beer 85
White Rock Beer 58
White Rock Dairy 63
Wiener, Emmanuel 85
Wirth, Joseph C. 24

Wolf Ledge Brewery 38, 39
Woman's Christian Temperance Union 67
World War II 21, 81, 86, 110

Z

Zepp 69, 79

ABOUT THE AUTHOR

Robert A. Musson, MD, is a native of Akron and a graduate of both the University of Akron and The Ohio State University. In 1976, at the age of thirteen, he began to follow a popular fad of collecting beer cans, and within twenty years, he had accumulated more than eight thousand varieties. Along the way, he developed an interest in collecting other breweriana, such as labels, signs, bottles, trays and other items. In 1994, he first began to research the history of the local brewing industry, which led to his first self-published book, *Brewing Beer in the Rubber City*, in 1997. Since that time, he has published thirty-five more titles, including five with Arcadia Publishing. Most of his works involve the history of the brewing industry in Ohio, Pennsylvania and West Virginia, although he has also written histories of Federal Highways 21, 22 and 250.

Currently residing in Medina, Ohio, with his wife, Jennifer; their daughters, Anastasia, Alexandra and Athena; and two cats, he is a practicing physician, specializing in circulatory problems in the legs. Although he sold his brewery relic collection years ago, he continues to collect historical information and images, with the intention to continue writing well into the future.